NIAGARA FALLS
FOR EVERYBODY

What to See and Enjoy—A Complete Guide

BARBARA A. LYNCH-JOHNT

AMHERST MEDIA, INC. ■ BUFFALO, NY

Dedication

To my mom and dad, who descended from a line of proud immigrants who chose to make Niagara home. To my brother, Rob Lynch, who never tires in his efforts to improve the city of Niagara Falls, New York. To my daughter, Madeleine Lynch-Johnt, who inspires me with her strength and wit. Finally, to Bob Roland, who was eager to accompany me on many a photo journey, hauled my gear, served as my sounding board, and did the research and writing for chapter 2. I am grateful for the impact each of you has had on my journey.

Published by:
Amherst Media, Inc.
PO BOX 538
Buffalo, NY 14213
www.AmherstMedia.com

Publisher: Craig Alesse
Senior Editor/Production Manager: Michelle Perkins
Editors: Barbara A. Lynch-Johnt, Beth Alesse
Acquisitions Editor: Harvey Goldstein
Associate Publisher: Katie Kiss
Editorial Assistance from: Carey A. Miller, Roy Bakos, Jen Sexton-Riley, Rebecca Rudell
Business Manager: Sarah Loder
Marketing Associate: Tonya Flickinger

ISBN-13: 978-1-68203-322-7
Library of Congress Control Number: 2017949333
Printed in the United States of America
10 9 8 7 6 5 4 3 2 1

www.facebook.com/AmherstMediaInc
www.youtube.com/AmherstMedia
www.twitter.com/AmherstMedia

CONTENTS

THE GEOGRAPHY AND HISTORY OF NIAGARA FALLS

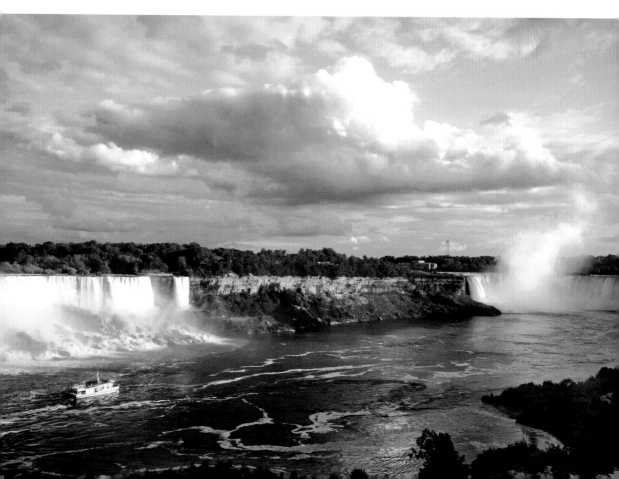

OFF THE BEATEN PATH:
OTHER POINTS OF INTEREST

About the Author

Born in Niagara Falls, New York, Barbara A. Lynch-Johnt is a lifelong native of the Western New York area. She earned a BS in Sociology and a BA in English from the State University College at Buffalo and has worked in the publishing industry since 2000. She is the owner of Basia Photography and specializes in wedding photography, fashion shoots, and fine art photography. Her images have been exhibited in several local galleries and are sold on numerous stock websites, including Adobe Stock, Shutterstock, and Alamy. She is the coauthor of *Illustrated Dictionary of Photography: The Professional's Guide to Terms and Techniques for Film and Digital Imaging* (Amherst Media, 2008). To see more of Barbara's work, go to www.basiaphoto.com.

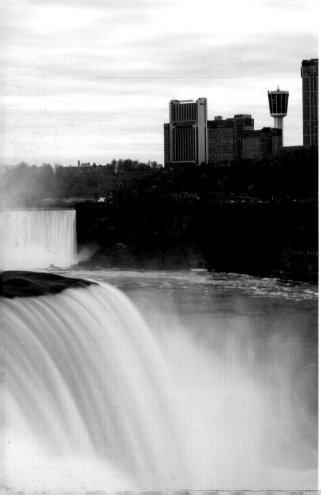

INTRODUCTION

When I was a kid, my mom dragged my brother and me to the Falls more times than we could count. In the 1980s, we had a constant stream of relatives arriving from Poland, seeking shelter in my Babci's home. The prospect of seeing Niagara Falls was, for them, exciting. But I had better things to do. I had seen enough falling water, winding walkways, trees, and rocks to last a lifetime. I dreamed of a bigger life; Toronto was more my speed. I had to be in a city with a pulse. I desperately wanted out.

I never did leave home. The farthest I managed to venture was to Buffalo, a mere 20 minutes from my old hometown.

The irony that I've found myself writing a book on the Niagara region—telling stories of its discovery, heyday, downturn, and resurgence—is not lost on me. It's been a fascinating personal journey. I have found myself turning over rocks to see what lies underneath. I have retraced the steps I loathed taking, this time with awe. I have armed myself with a camera and a desire to see differently. To chronicle my birthplace. To celebrate what was, what is, and what will be.

I find myself writing a love story. There's a heartbeat here. A pulse.

Welcome to Niagara.

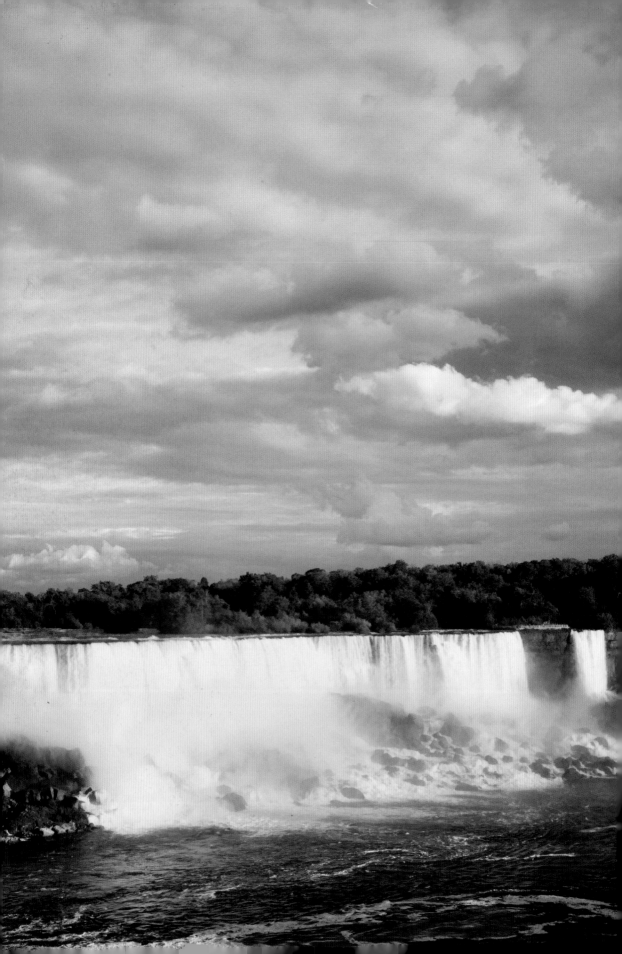

The Geography and History of Niagara Falls

"Niagara-Falls! By what mysterious power is it that millions and millions, are drawn from all parts of the world, to gaze upon Niagara Falls? There is no mystery about the thing itself. Every effect is just such as any intelligent man knowing the causes, would anticipate, without [seeing] it. If the water moving onward in a great river, reaches a point where there is a perpendicular jog, of a hundred feet in descent, in the bottom of the river—it is plain the water will have a violent and continuous plunge at that point. It is also plain the water, thus plunging, will foam, and roar, and send up a mist, continuously, in which last, during sunshine, there will be perpetual rain-bows. The mere physical of Niagara Falls is only this. Yet this is really a very small part of that world's wonder."[1]

—Abraham Lincoln

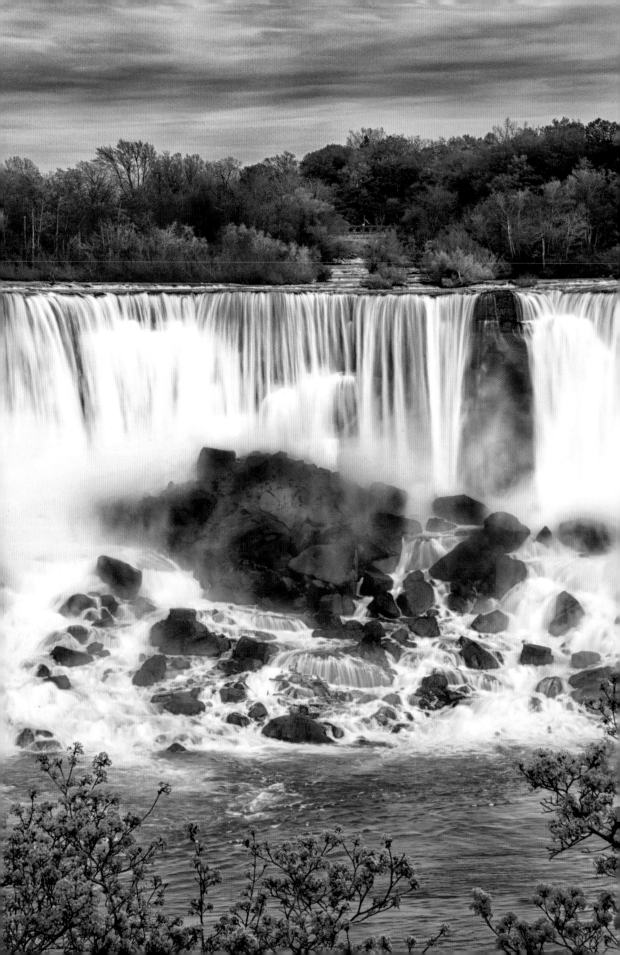

1. WELCOME TO NIAGARA

Niagara Falls is the collective name for three distinctive, powerful waterfalls—the Horseshoe Falls, American Falls, and Bridal Veil Falls. The Falls are located on the Niagara River and straddle the border between the United States and Canada.

■ THE HORSESHOE FALLS (below)

The Horseshoe Falls, sometimes referred to as the Canadian Falls, takes its name from its curved crest. It is the largest of the three Falls, and the majority of it is located on the Canadian side of the international boundary line. Its width, at the brink, is 2600 feet/792.4 meters, and it is 167 feet/50.9 meters high. The volume of water that falls over the brink is estimated to be an incredible 600,000 U.S. gallons/2,271,000 liters per second.[2] In fact, though, the volume of water that flows over each of the Falls is variable. There are two hydroelectric plants that draw water into their reservoirs before the water reaches the Falls, and this affects the overall flow volume. However, peak flow is reached during the daytime in the months of June, July, and August.

The powerful flow causes a continual erosion of rock. Since the Falls formed over 12,000 years ago, their position has slowly shifted. The erosion rate is estimated

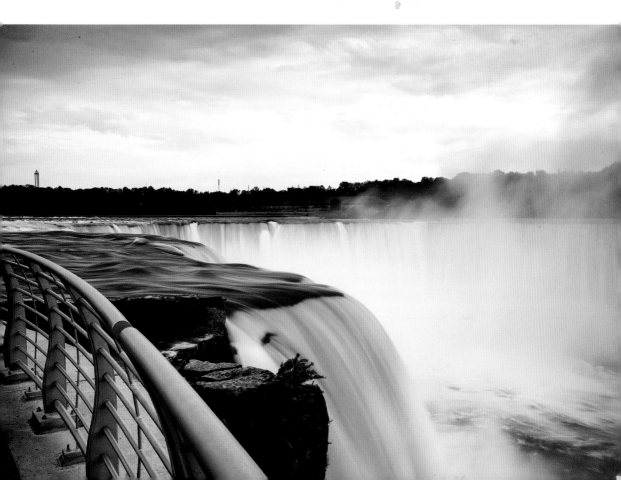

at 1 foot/0.3048 meters per year for the Horseshoe Falls. The American Falls erodes more slowly—just 2 to 3 inches/5.08 to 7.62 centimeters per year, due to the lower volume of water that flows there.[3]

The Horseshoe Falls can be easily viewed by visitors to the Niagara Falls State Park from Terrapin Point on Goat Island. Visibility is also good from Queen Victoria Park in Canada.

The Horseshoe Falls is not the tallest waterfall in the world, but the sheer volume of water that thunders over its brink makes it uniquely impressive.

■ THE AMERICAN FALLS

The American Falls is situated wholly in the United States. The second-largest of the three waterfalls, it measures 1075 feet/327.66 meters wide and 110 feet/34 meters high.

■ THE BRIDAL VEIL FALLS

The Bridal Veil Falls is the smallest of the three waterfalls that make up Niagara Falls. It is located on the American side of the Niagara River. Luna Island separates it from the American Falls, and Goat Island separates it from the Horseshoe Falls. The Bridal Veil Falls faces to the northwest and has a crest 56 feet/17 meters wide and a height of 181 feet/55 meters.[4]

Visitors can get quite close to the American and Bridal Veil Falls on the U.S. side of the border, but they are, from this vantage point, seen only from a steep angle. Crossing over to Canada allows for a wider view of the Falls, though it will be viewed from a greater distance.

■ A POWERFUL FORCE

The waters of the Niagara River serve over a million United States and Canadian residents in a wide range of ways: the Niagara generates hydroelectric power, provides drinking water, and allows for recreational uses, such as fishing and boating. Of course, for safety reasons, there are laws and restrictions against boating in the rapids.

Goat Island

Goat Island, once known as Iris Island, is a small island in the Niagara River, located in the Niagara Falls State Park between the Bridal Veil Falls and the Horseshoe Falls. It is called Goat Island because an 18th-century pioneer named John Steadman kept goats there, and one is said to have survived a particularly harsh winter.

Goat Island is a popular destination for visitors to Niagara Falls, New York, as it offers pedestrians spectacular views of the Falls. There is ample parking to be found in one of the State Park's parking lots. Current rates are $10.00 per day for cars.

Goat Island is connected to the U.S. mainland by two bridges that facilitate travel by foot and by car. Luna Island (adjacent to the American Falls) can be accessed via a pedestrian bridge.

Goat Island is picturesque and largely wooded. Numerous foot trails allow for exploration. The Cave of the Winds tour elevator provides access to the foot of the Falls.

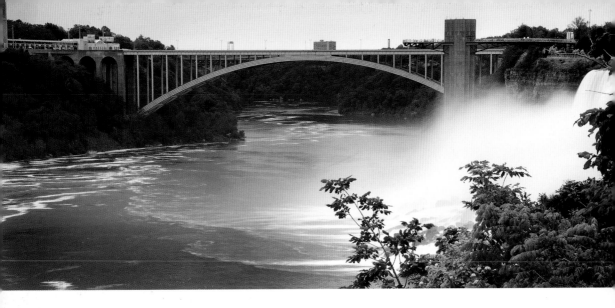

■ TRAVEL BETWEEN THE U.S. AND CANADA

There are many important steps to take before you cross the border between the United States and Canada. Please take into consideration the documentation that is required, toll fees, currency exchange rates, and other issues that apply to international travel, whether you choose to take a scenic walk across the Rainbow Bridge or plan to travel by vehicle. For more information, go to https://travel.state.gov/content/passports/en/country/canada.html. Also, be sure to check with your mobile service provider regarding international calls and data usage.

Different currencies are used on each side of the international border. If you are using a credit card/bank card, the issuing bank will handle the exchange rate and thereby determine how much your money is worth. If you will be paying with cash, consider having a sum exchanged so that you can shop for the best exchange rates and make the most of your money.

Interesting fact: A marker on the Rainbow Bridge designates the international boundary point. If you opt to walk across the bridge, be sure to stop and take a picture to chronicle the border crossing.

Things Change

At some point, there will be new businesses in the area, new things to see, and new things to do. For up-to-the-minute information that may prove helpful to you years from the time this book was published, check out the following websites. These sites are a good place to go to access maps, which may come in handy when you are planning your trip.

Niagara Falls, New York
- www.niagarafallslive.com
- https://parks.ny.gov
- www.niagarafallsusa.com

Niagara Falls, Canada
- www.niagaraparks.com
- www.niagarafallstourism.com
- https://niagarafalls.ca

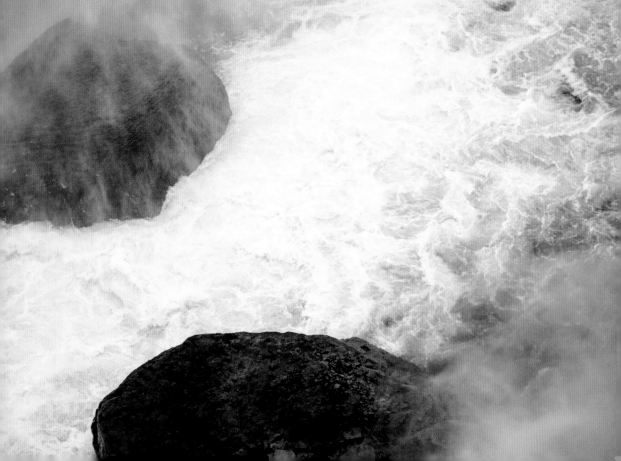

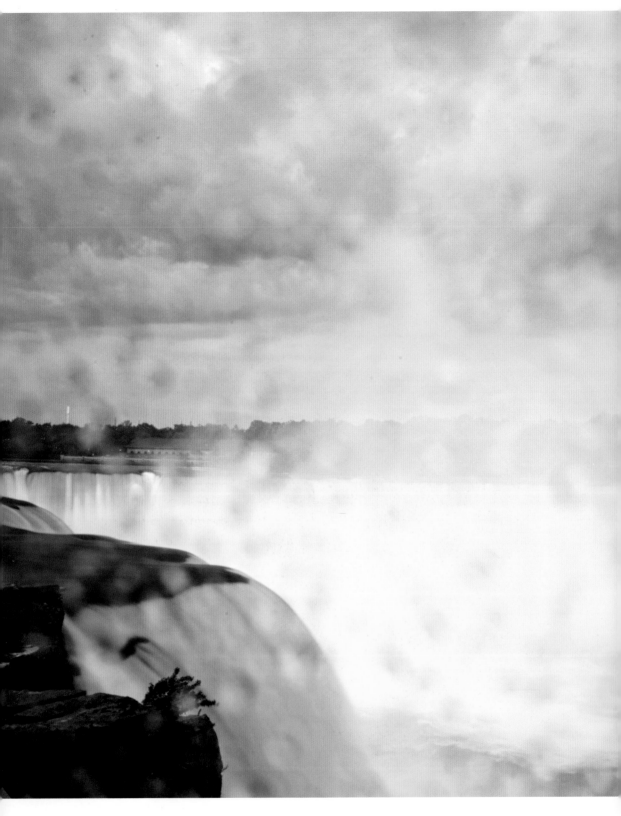

■ PUT YOUR BEST FOOT FORWARD

Here's an early-morning view of the Horseshoe Falls from Terrapin Point on Goat Island. There was a heavy spray of mist on my camera lens, which is visible in the image. You may want to protect your camera or smartphone from water spray when you are viewing the Falls to avoid damage. You may also want to consider bringing an extra layer of clothing with you, as it tends to get a little chilly even on moderately warm days.

■ A SNEAK PEEK

Want to steal a look at the Horseshoe Falls before you embark on your journey? You can view live footage captured from the Hilton Fallsview Hotel in Niagara Falls, Canada. Go to www .niagarafallslive.com/ niagara_falls_webcam.htm to view real-time images from a web cam.

2. A BRIEF HISTORY

■ EARLY HISTORY

At the end of the last Ice Age, glacial waters rushed down from Lake Erie and through the Niagara Escarpment, carving pathways, such as the Niagara River. As the waters rushed, the first Falls were formed—a single cataract, located downstream. Spruce trees dotted the frozen tundra. After the Ice Age ended, the land warmed and forests grew. It was at this juncture that the first people moved onto the land. A succession of people called the region home, including the Clovis, Lamokas, and Hopewells. The Hopewell culture, also known as the Mound Builders, cultivated large farming communities, smelt copper, and introduced tobacco to the region.[5]

The most important cultural impact, however, came from the Iroquoian people hundreds of years later. Drawn by the region's rich soil, fish, and game, the tribes that made up the Iroquois Confederacy called the Niagara region home.

Warfare between the tribes was commonplace until the 12th century, when Dekanawida, aided by his spokesperson Hiawatha, gathered together representatives of five tribes in Victor, New York, and established the Great Law of Peace. Not much is known of the identity of Dekanawida. In some ways, he appears as an almost mythic figure, including a virgin birth.

Western New York became land of the Seneca people, and many of our place names come from them. The influence of Native Americans plays a vital role in the culture of Niagara Falls.

■ ARRIVAL OF THE EUROPEANS

In 1535, Europeans, exploring the waterways of the New World, first heard stories of Niagara Falls. Jacques Cartier mapped a large segment of the St. Lawrence region and marked the region "Canada." Later cartographers, such as Samuel de Champlain, used the Iroquois word "Onguiaahra," which would later be known as "Niagara."

For the next 150 years, expeditions to the region would be launched, but there is no evidence that any European saw the Falls.

In 1678, a French priest, Antoine Hennepin, joined the La Salle expedition and went down in history as the first European to document seeing Niagara Falls in person.

Later, members of the expedition would build the first European settlement on the Niagara River, Fort Conti, which later became Fort Niagara. Hennepin would go on to write the first book on the area, entitled *New Discovery,* which was popular in its original French and in its English translation. By the end of the 17th century, people began to travel to the area to gaze upon the powerful Falls.

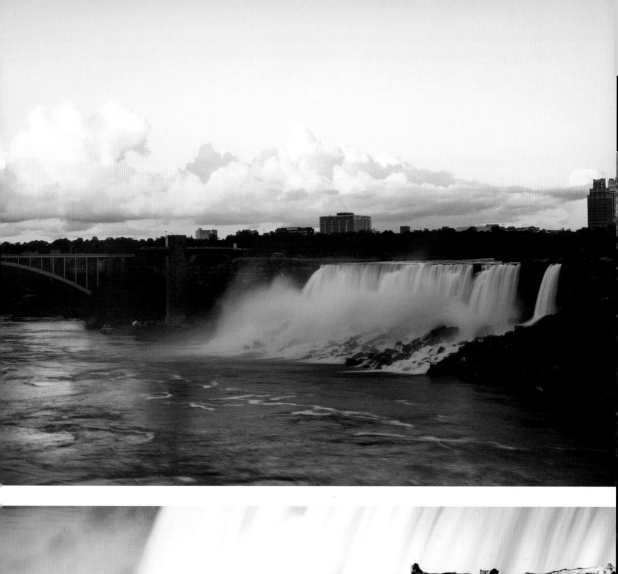
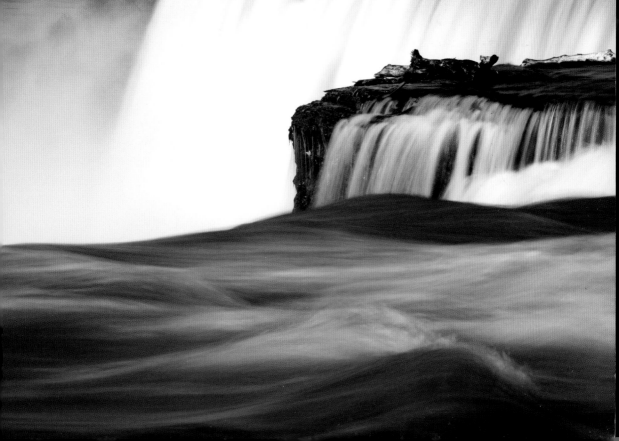

WAR AND THE ROUGH FRONTIER

Between 1754 and 1763, the area was embroiled in the French and Indian War, pitting England against France. The English seized Fort Niagara in 1759. The war ranged across North America, with the result being a decisive victory by England.

Few European settlers arrived during this time period. The land was owned by the Iroquois Confederacy. Those Europeans who did arrive lived close to Fort Niagara. As the Revolutionary War began, the settlement of Butlersburg, now Niagara-on-the-Lake, served as a safe haven for British loyalists.

NIAGARA FALLS SEPARATED BY A BORDER

After the War of Independence, the Jay Treaty defined the border of the United States. Niagara Falls could no longer be referred to as one area, but instead two separate nations. Within a generation, there was a final war in the area.

The War of 1812 saw the heaviest fighting the region had experienced to date. The newfound settlements on both sides of the international border found themselves burned and ravaged by warfare. Dead soldiers outnumbered the living. Those who did not find their homes destroyed had trouble finding employment, as all commerce ceased.

From the war, two Niagara Falls were born, and both followed different paths to become the cities they are today. Out of the war, one of the most peaceful borders was created. Trade flourished between the two nations, and both sides made strides to allow easy border crossings.

NIAGARA FALLS IN THE 19TH CENTURY

The lush landscapes, good farmlands, and access to the Great Lakes made the region prosperous. America and Canada welcomed a new generation of settlers, as cities began to appear throughout the Falls region.

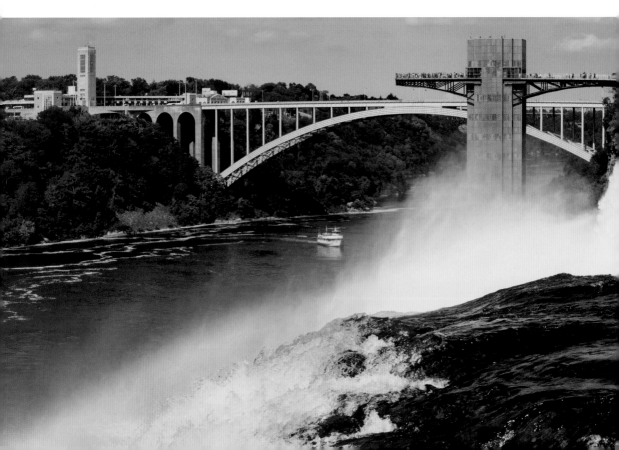

For the Americans, the advent of the Erie Canal made towns throughout Niagara County wealthy. Providing a way to reduce the cost of transporting goods, the canal became a major thoroughfare. Over 50,000 people made their living on the canal. Both commercial and pleasure craft found their way down the canal, and the passengers experienced the Niagara region for the first time.

Niagara has an ideal climate and soil for farming, and the power of the Niagara River and the Falls themselves provided the perfect setting for fledgling industry. The lakes were bountiful for both trade and fishing. More importantly, there was another industry beginning to emerge in the region: tourism.

From the first description of the Falls and its majestic waters, people traveled far to catch a glimpse. Both the American side and the Canadian side were set to capitalize on the rise of tourism. As luminaries began to spend their honeymoons in the Falls, the rush was on to craft an ideal experience. Soon, small boarding houses would gave to majestic hotels. In 1824, on the site where the Fallsview Tower Hotel stands in Canada today, William Forsyth built the Pavilion Hotel, a three-story structure overlooking the Falls. In the United States, General Parkhurst Whitney erected the Eagle Hotel. Both men worked together to craft the Niagara Falls experience. Some of their experiments in promotion, however, would go too far.

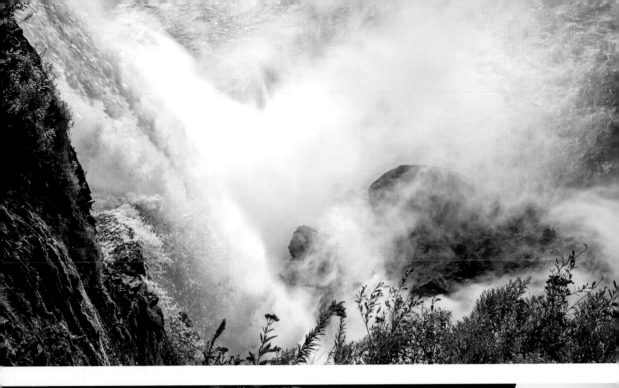

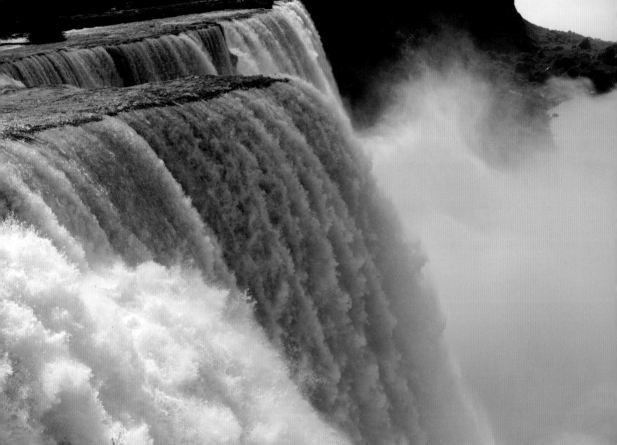

In 1827, the two men purchased an old condemned lake schooner named "The Michigan" and advertised that they would send the vessel over the Horseshoe Falls, manned by a collection of wild animals. Over 15,000 people flocked to the Falls on September 8th to watch the spectacle.

Accounts differ on the animals that were on board the doomed ship. Some say that there were deer and pheasants. Others claim raccoons, dogs, and geese. One thing is for sure: on board were two brown bears. As the ship, dressed to look like a pirate vessel, approached the rapids of the Horseshoe Falls, it began to break apart and take on water. As the animals on board began to panic, the two bears jumped into the water and swam to Goat Island, as the vessel carried the other animals over the Falls and to their deaths.

Thankfully, tourist promotions today are far kinder to animals.

Tourism continued to grow during the 19th century. In 1829, a staircase was built at the base of the Bridal Veil Falls, and visitors could experience the Cave of the Winds for $1.00. In 1846, the first Maid of the Mist boat was built, and in 1860, the Falls was illuminated for the first time.

Not every visitor walked away impressed. Oscar

Wilde once remarked that visiting Niagara Falls would be "the bride's second disappointment." This view, of course, was the minority.

With the development of railroads, people from all over Canada and across the United States made Niagara Falls their honeymoon destination and took delight in the amusement parks, attractions and, of course, the Falls themselves.

Others were attracted by the sheer power of Niagara Falls and dreamed to harness its power for industry. The first person to attempt to use the Falls for industry was

Daniel Joncairs. In 1759, he dug a ditch and used the rushing water to power his sawmill.

Augustus and Peter Porter, whose surname marks streets in Buffalo, Niagara Falls, and Lockport, acquired the water rights for the American Falls in a public auction. They dreamed of a canal that would generate power. Sadly for the Porters, their schemes would not become profitable. The rights, in 1853, were sold to the Niagara Falls Hydraulic Power and Manufacturing Company, which realized the dream of creating a power-generating canal. However, the new owner, Horace Day, would find no more success than the Porters.

Still, interest in industry grew in the area. The advent of electricity was the final ingredient needed to harness the power of the Falls. In 1881, the first electrical generating station was built, and others followed.

■ ENVIRONMENTAL AWARENESS

By the end of the 19th century, it became clear that steps would need to be taken to preserve the

aesthetic beauty of the Falls. Factories dotted the landscape, and public access was limited by property rights. Both Americans and Canadians built parks for people to enjoy the beauty of the Falls.

In 1873, in an attempt to combat what was perceived as high levels of crime and vice in Canada, Edmund Burke Wood proposed to the Canadian parliament a plan to create a national park. Initially rejected in favor of a privately owned concept, plans for the 118-acre Queen Victoria Park won out. Buildings were torn down and the park was built and opened to the public on the Queen's birthday in 1888.

In America, awareness of the need to preserve the natural beauty came as early as 1833, when New York Governor Grover Cleveland signed a bill to create the Niagara Falls Reservation. This land became part of the Niagara Falls State Park, the first State Park in the nation. Established in 1885, the park spanned 400 acres. Famed landscape artist Fredrick Law Olmsted, who designed Central Park in New York and parks in western states, such as Denver, helped to shape the landscape. He believed the natural beauty of the water and the vegetation were vitally important to the spiritual well-being of residents and visitors. His landscape would include the purchase of Goat Island, where buildings would be torn down and plants would be allowed to flourish. Footpaths were created to lead visitors down a path of beauty and serenity. These path are still used today.

The debate over the environment would continue for decades more. Who owned the water? Who would dictate the development along the Niagara River? Who had the rights to harness the power of the Falls?

Early in the 20th century, many of those questions were resolved. In 1900, Thomas C. Platt, a senator from New York, called for the establishment of a committee to settle issues along the international border.

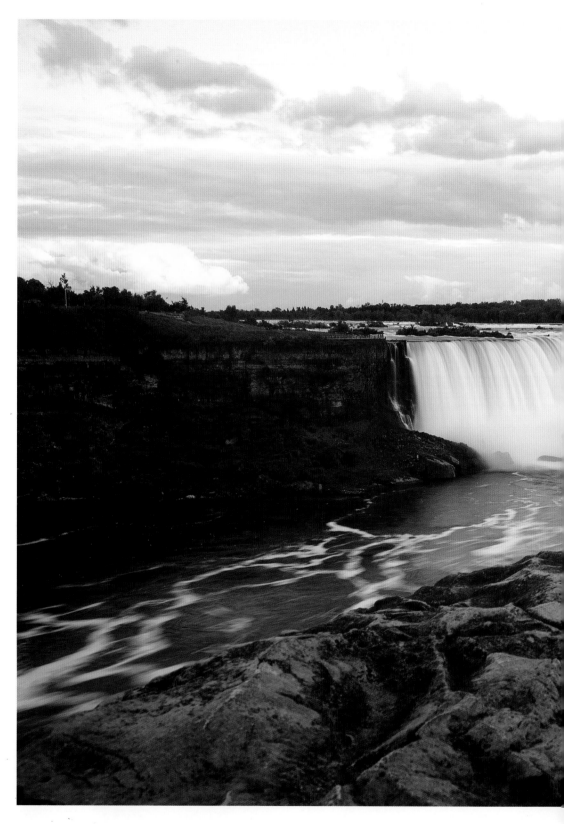

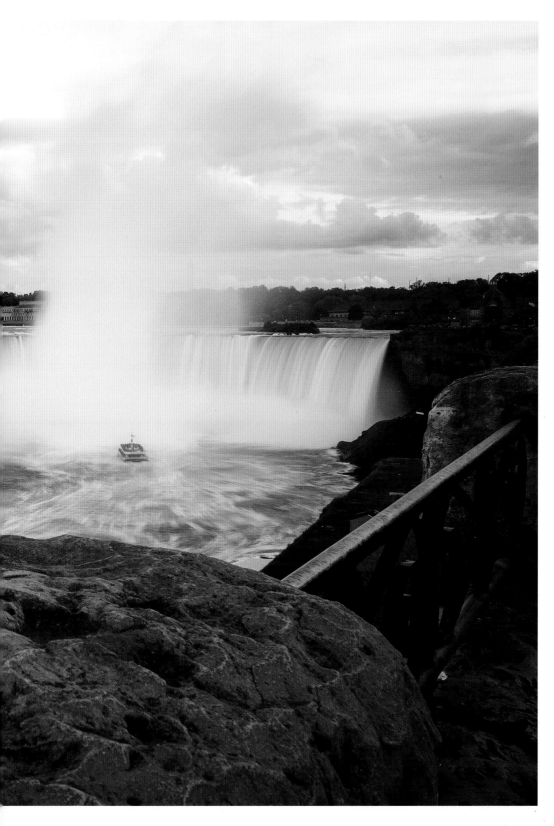

Teddy Roosevelt helped to push the matter forward, creating a framework that halted the practice of dumping tremendous amounts of pollutants into the waters.

■ THE 20TH CENTURY: CITY OF LIGHT

In 1886, the first plan was proposed for a power generator that would bring electricity to Niagara Falls and Buffalo. There was just one problem: how to transmit the power from the generator to the cities?

An award of $100,000.00 was offered to the person who could find a solution. There were no takers. A commission was formed, led by Lord Kelvin. The most important debate would revolve around the method of transmission. Should it be transmitted via direct current or alternating current?

Alternating current won out, supported by the Westinghouse Corporation, led by brilliant engineer Nikola Tesla, a Serbian-born engineer who worked tirelessly on the project. Finally, on November 16th, 1896, a switch was thrown and electricity was sent to Buffalo, New York. Buffalo would become known as the "City of Light" due to the power of Niagara Falls.

Over the next few decades, additional power plants were built. Construction of the Schoellkopf Power Station began in 1895. In 1956, the ground under the plant gave way, collapsing the gigantic building. Today, one can walk down to the river, where remnants of the building still remain.

■ YEARS OF PROSPERITY, SEEDS OF DISASTER

For the next six decades, the region would become a mighty economic powerhouse. The cheap electricity, infrastructure, and continual influx of immigrants led to a golden era of commerce. Tourism took a back seat, especially on the American side, as chemical and mechanical engineering became dominant.

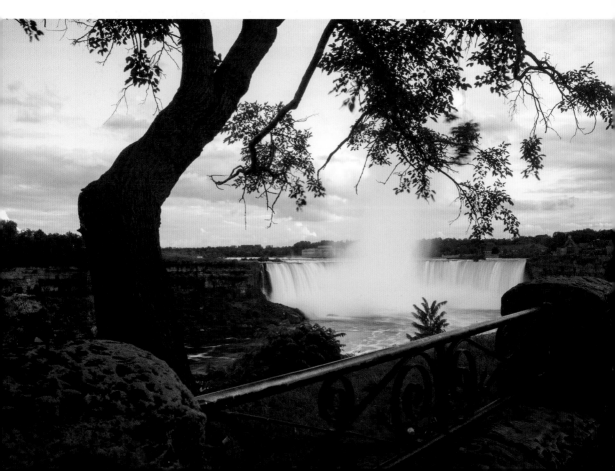

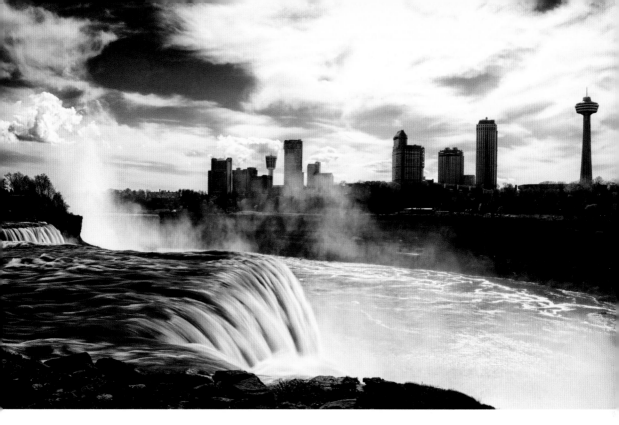

The face of tourism began to change. For years, one of the most popular attractions was the "Frozen Falls." Visitors headed out onto the ice-covered Niagara River to enjoy skating and games. Tents were set up, complete with musicians and food trucks. In 1912, this practice ended, as a chunk of ice broke off, carrying three tourists to their deaths. The golden era of tourism was also hit hard by the Great Depression, and the Falls saw fewer and fewer visitors.

If there was a bright spot for the Niagara region during the Great Depression, it was prohibition. With alcohol sales made illegal in America, yet legal in Canada, traffic across the border increased as thirsty Americans flocked to Ontario bars.

With the changing economic conditions on both sides of the border, more factories were built, and farming and tourism took a back seat. The median income of residents rose, and a strong blue-collar employment sector was born. Old hotels were demolished to make way for middle-class homes.

This path sowed the seeds of disaster for Niagara Falls, New York. By 1920, industrial waste and pollution spilled into the Niagara Gorge. A failed canal, built by industrialist William Love, become a toxic waste dump into which Hooker Chemical disposed of over 22,000 tons of dangerous chemicals.

Driving along the Niagara River on the American side, it's clear how important industry was in the city. Instead of neon-lit tourist areas like you see in Canada, the lights of Niagara Falls, New York, come from factories that dot the landscape.

On the Canadian side of the border, tourism remained a key objective. In the

1960s, the Seagram Tower (now known as the Fallsview Tower Hotel) was built, containing a restaurant, wedding chapel, and hotel. Attractions such as the Ripley's Believe It Or Not! Museum and the Hollywood Wax Museum were built on Clifton Hill; both are open to this day.

The 1970s saw another period of economic turmoil when a powerful recession devastated manufacturing in America. Instead of an image of majestic beauty and clean hydroelectric power, the image most would have of Niagara Falls, New York, would be that of failed industry and environmental nightmares such as the Love Canal site.

■ THE ROUGH DECADES

In the early 1970s, Niagara Falls, New York, had a population of close to 100,000 people. By the end of the 20th century, the population would be half that.

Love Canal, in many ways, serves as a metaphor for what happened in the city. Hooker Chemical, in 1952, had filled the abandoned canal with as much chemical waste as it could handle. The canal was covered with clay to prevent the leakage of chemicals, and the site stood empty. The City of Niagara Falls approached Hooker Chemical with an offer to buy the land to use as a site for a new school. Hooker agreed, believing that the sale would absolve the company of liability for the waste.

As development began on the site, construction caused the chemicals to directly leak into the ground. As a housing development grew over the site, dioxins, benzene, chloroform, and PCBs seeped into the water. Children playing in the park reported chemical burns on their hands, and black ooze and dangerous gases were found in residents' basements.

Community activists began to draw attention to the issue in the early 1970s. City and state officials were slow to react, but it became clear that this was too great a problem to ignore. In 1978, President Carter visited Love Canal and declared it a disaster zone, relocating hundreds of families. By the 1980s, the remaining families would leave, and only a ghost town would stand on the site. Today, the Love Canal neighborhood appears as an open field, with few structures remaining.

Love Canal was a black eye for the region, but it was not the only challenge to plague Niagara Falls, New York. The loss of manufacturing jobs also led to rampant unemployment and a flight of residents from the city. By the start of the 21st century, the population was less than half of what it was 30 years earlier. Poverty and crime remained issues.

■ NIAGARA FALLS, CANADA: ECONOMIC REVIVAL

Increasingly, tourists to the Niagara region chose the Canadian side of the Falls for their travel destination. With clean parks, shining observation towers, museums, and other attractions, Niagara Falls, Canada, thrived while Niagara Falls, New York, declined. The Canadian side also benefited from a favorable currency exchange rate, offering a great value for tourists from other countries.

In the 1990s, the Ontario government legalized gambling, and luxury hotels began

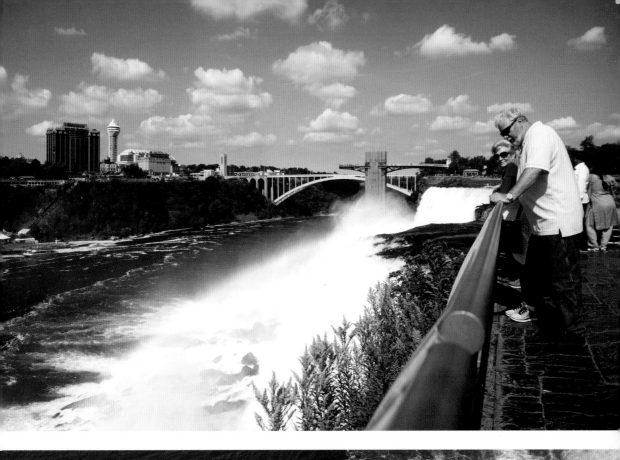
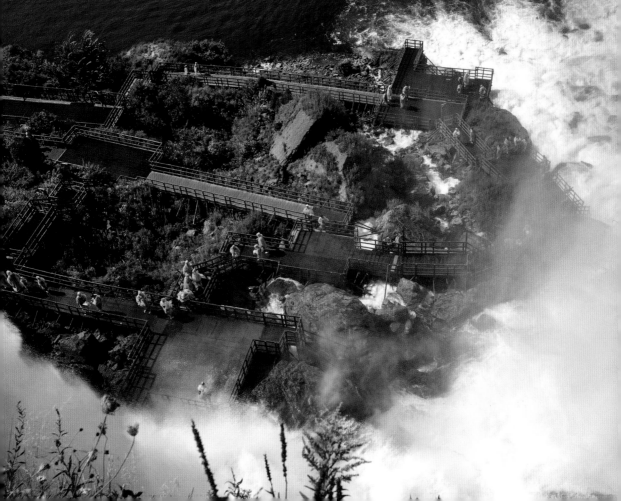

to be built. American attempts to recapture the tourist trade did not fare as well. Soon, Niagara Falls, Canada, would see nearly 4 million more visitors each year than Niagara Falls, New York, would.

■ A NEW HOPE IN THE 21ST CENTURY

If history has shown us anything, it's that Niagara Falls always finds a way to reinvent itself. A drive down Third Street in Niagara Falls, New York, makes it clear that there are emerging businesses and a renewed vibrancy in Niagara Falls, New York. On other streets, old schools are being converted into art

complexes. Murals are popping up on the sides of buildings. New bars and restaurants are opening. Culinary centers and schools specializing in the hospitality industry are making their home in Niagara Falls. The low cost of real estate is making it attractive for people to stay in or move to the city, and young people are finding more and more job opportunities. It's clear that the future of Niagara Falls is going to be bright.

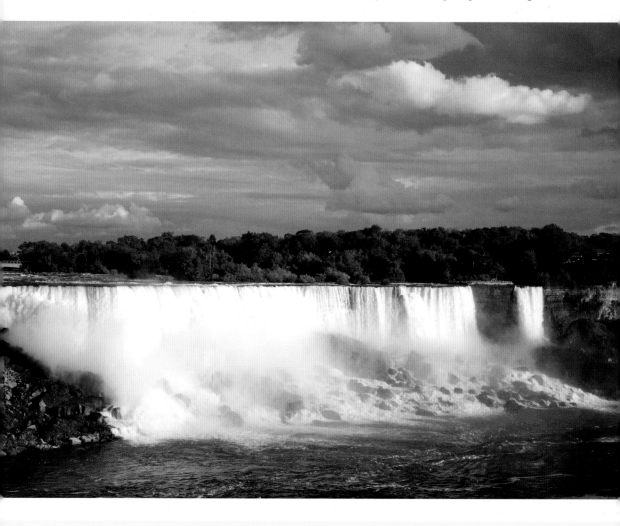

#LiveNF

A hashtag is a type of metadata tag used on social network sites that allows others to easily find messages with a specific theme or content. When you visit Niagara Falls, New York, and want to allow others to easily view your images or read stories about your travels, simply add the tag #LiveNF to your message. Of course, you can also use the tag to look for cool things to do as you plan your adventures in Niagara Falls, New York. Enjoy!

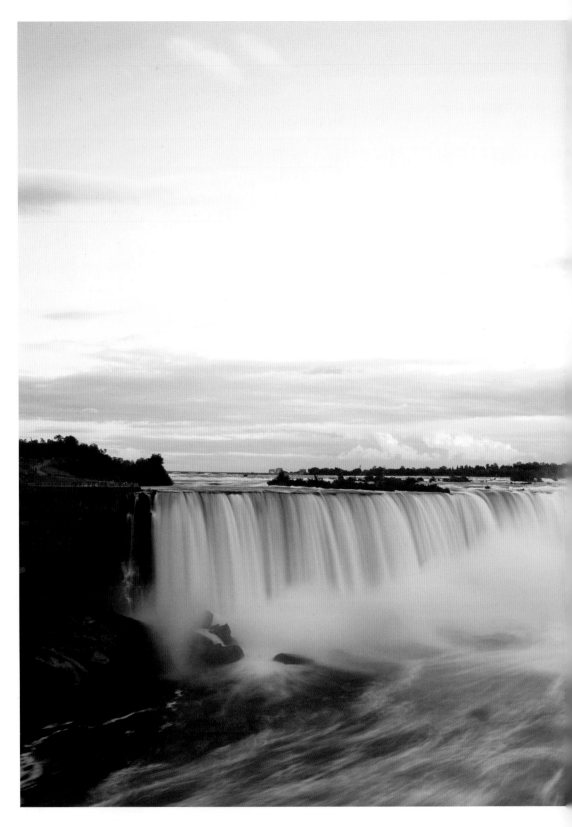

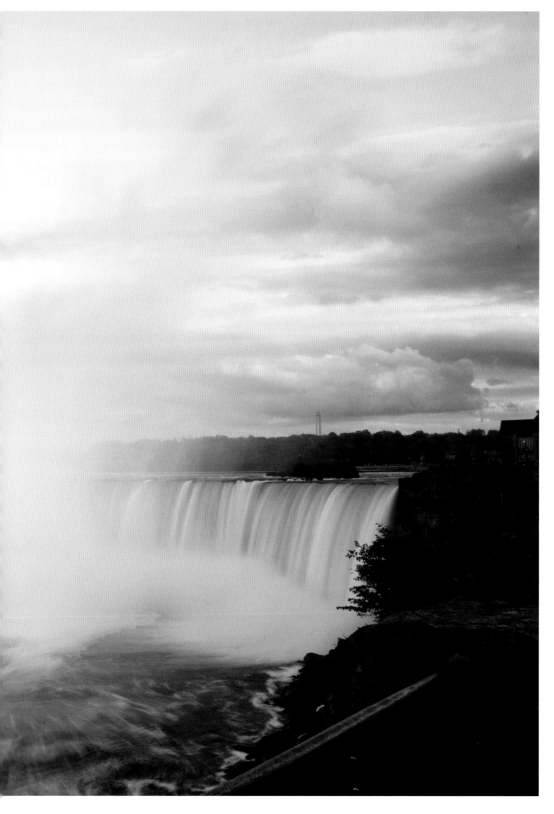

3. FAMOUS FACES

■ THE FIRST HONEYMOONERS

In 1802, Theodosia Burr, daughter of U.S. Vice President Aaron Burr, made a post-nuptial trip to Niagara Falls with her new husband, Joseph Alston.

Two years later, in 1804, Napoleon Bonaparte's brother Jerome and his new wife, Elizabeth Patterson, followed suit.

When the Erie Canal opened and new railways facilitated access to the Niagara region, numerous couples began to make their journey to the thundering waters, and Niagara Falls earned the moniker "the Honeymoon Capital of the World."

■ NIKOLA TESLA

When Nikola Tesla (1856–1943) was a child, he was mesmerized by the power of the Falls. As an adult, he designed the first hydroelectric power plant in Niagara Falls, New York, and began to harness its power. A statue of Tesla overlooks the Falls on Goat Island. He holds an open book in his lap, and parents often take pictures of their kids sitting on it. There is a statue of Tesla in Niagara Falls, Canada, too; it faces the Falls.

Tesla's contributions to the region and to hydropower in general cannot be denied.

■ MARILYN MONROE

When the 1955 film noir classic *Niagara* was filmed in Niagara Falls, Ontario, Marilyn Monroe and her costars Joseph Cotten and Jean Peters stayed in a hotel formerly known as The General Brock. The hotel, established in 1929, is now called the Crowne Plaza Hotel, and Marilyn's room—801—is still available. Also, photos captured of Monroe during filming adorn the 8th floor.

Niagara features striking footage of the Falls. Visitors can head to the Skylon Tower in Niagara Falls, Canada, or to the Observation Tower in Niagara Falls, New York, to get the view shown in the heralded film.

Interesting fact: Andy Warhol used a publicity photo from *Niagara* as the basis for his silkscreen painting, *Marilyn Diptych*, which shows multiple images of the actress's face.

Marilyn and her costars are not the only notables to have stayed on premises. Walt Disney, Shirley Temple, Jimmy Stewart, Princess Margaret, Queen Elizabeth, Sylvester Stallone, Matt Dillon, Bruce Willis, and Jackie Chan have also had rooms in the historic hotel.

Locating the Crowne Plaza Hotel is easy. It's at 5685 Falls Avenue, directly across from the Rainbow Bridge.

■ PRINCESS DIANA AND SONS

The Royal Family paid a visit to Niagara Falls in October of 1991. They dined in the Commissioner's Quarters of the Victoria Park Restaurant (now called Edgewaters

Restaurant) and had a private tour of the Falls on the Hornblower.

CHRISTOPHER REEVE

Christopher Reeve and costar Margot Kidder filmed portions of *Superman II* (1979) in front of hundreds of onlookers. The scenes were shot by the Horseshoe Falls. In one scene, Superman saves a boy who tumbles over the rail above the waterfall. In another scene, Lois Lane throws herself into the raging waters to coax Clark Kent into his superhero persona—but he manages to save her without donning his cape.

JACK LEMMON

Actor Jack Lemmon starred in the 1967 romantic comedy, *Luv*. The actor played Harry Berlin, a depressed man who falls for the ex-wife of a friend. Harry and his love interest visit Niagara Falls for their honeymoon. Head to Prospect Point at the Niagara Falls State Park to retrace the actor's steps.

ROY SCHEIDER

If you love thrillers with big twists, you'll want to check out *Last Embrace* (1979) starring Roy Scheider. The film follows Scheider as a U.S. government agent afraid for his life. Niagara is the backdrop for the film's climax; the actors traverse the Falls landscape and make their way through the hydroelectric power plant, too.

JIM CARREY

Niagara Falls makes an appearance in Jim Carrey's comedic film, *Bruce Almighty* (2003). Carrey plays the role of Bruce, a down-on-his-luck news reporter who is granted the omnipotence of God, but soon learns that the role comes with some daunting responsibilities. Early in the film, Carrey interviews a captain of the Maid of the Mist. Check it out before taking your own ride on the famous boat.

Interesting fact: In *Pirates of the Caribbean: At World's End*, Captain Barbossa sails the Black Pearl to the edge of the earth to save Captain Jack Sparrow. Remember when Barbossa drops over a huge waterfall? Yes. That is the Horseshoe Falls. To get the perfect shot, Hollywood producers collaborated with Niagara Falls staff and hung a crane over the Falls.

I Was Here

Many great people from all walks of life were born and/or raised in Niagara Falls, New York. Amongst them are sports stars Rick Manning (former MLB player and current broadcaster) and Sal Maglie (MLB pitcher, scout, and pitching coach); musicians Tommy Tedesco (called the most-recorded guitarist in history, he played with Frank Sinatra, Elvis, and Ella Fitzgerald; his credits also include several famous TV theme songs) and Gary Baker (Grammy-winning singer/songwriter and vocalist); visual artists Thomas Aquinas Daly (landscape and still-life painter) and George Barker (19th century photographer); Lois Gibbs (environmental activist); actor Fred Beir (who appeared in *The Twilight Zone* and *The Rockford Files*); and numerous political, religious, and businesspeople of note.

Many notables sprung from Niagara Falls, Canada, too: electronic, dance, and house DJ Deadmaus 5 got his start in Niagara. Writer/director Sara Rotella, whose films appeared in 75 international film festivals and are hugely popular on YouTube, was born there, too. Hockey star Derek Sanderson (Bruins and Rangers) and pro skateboarder Chris Haslam also called Niagara Falls, Canada, their hometown.

4. DAREDEVILS

Niagara Falls has historically been a favorite haunt for stuntpersons. Some have taken limited precautions before plunging into the mighty waters or perching precariously above the rapids, while others were well prepared. A fair number of adventurers took on the raging waters in hope of earning fame and fortune, while others aimed to cheat death. All smartly chose to execute the feat over the Horseshoe Falls, due to the lack of rocks at its base.

In this chapter, I've provided brief descriptions of some of the best-known and most curious feats executed throughout history.

Interesting fact: Some of the barrels used by daredevils are displayed in the IMAX Theater's Niagara Daredevils exhibit, located at 6170 Fallsview Boulevard, Ontario.

■ WILLIAM FORSYTH

William Forsyth, a Canadian businessman, is reputed to have performed the first tourist stunt at Niagara Falls. He sent a schooner filled with live animals—and dummies tied to the deck—over the Horseshoe Falls at 6:00pm on September 8, 1827. The ship's occupants included a buffalo, two small bears, two raccoons, a dog, and a goose. As the schooner reached the rapids, its hull was torn open, and the vessel filled with water. The two bears jumped into the rapids and swam to safety at Goat Island. The other animals on board were caged or tied; when the boat reached the base of the Falls, the goose was the only survivor.

■ JEAN FRANCOIS GRAVELOT (following page, top)

Jean Francois Gravelot,[6] also known as the "The Great Blondin," made the first of his eight journeys across the Niagara River in 1859 on a 1100-foot tightrope. For his first walk, he used a 30-foot balancing pole weighing 40 pounds. It took him about 20 minutes to cross from the United States to Canada. On subsequent stunts, Gravelot complicated his feat. For one performance, he pushed a wheelbarrow across the wire. On another, he carried his manager on his back.

■ CARLISLE D. GRAHAM

In July 1886, daredevil Carlisle D. Graham, an English cooper (barrel maker), became the first stuntman to traverse the Niagara rapids in a barrel. To prepare for his stunt, he manufactured a 5.5-foot barrel made of oak staves and handmade iron hoops.

Graham was tall; he measured 6 feet in height and had to hunch over to allow the water-tight lid of the barrel to be secured. His body, exclusive of his arms, was protected by a waterproof canvas sheath. The stunt took 30 minutes. Graham lived but became very dizzy and fell ill after the ride. In August of 1886, he repeated the stunt—this

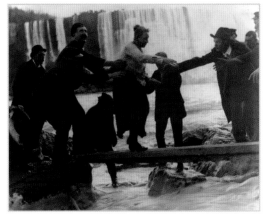

time, with his head outside of the barrel. Again, he survived, though this trip caused Graham to become hearing impaired.

The daredevil completed three similar stunts, later in a larger, 7-foot barrel.

If you'd like to pay homage to Graham, you can visit his grave site at the Oakwood Cemetery at 763 Portage Road, Niagara Falls, New York.

■ ANNIE EDSON TAYLOR (above left)

Annie Edson Taylor,[7] a widowed school teacher, was the first daredevil to plunge over the Horseshoe Falls in a barrel. She executed the stunt on October 21, 1901— her 63rd birthday—and suffered only a small gash on her head.

Taylor sought fame and fortune but died, penniless, at the Niagara County Infirmary in Lockport, New York. She is buried in the "Stunters Section" of the Oakwood Cemetery.

■ BOBBY LEACH (above right)

Following in Annie Edson Taylor's footsteps, Bobby Leach,[8] a Barnum and Bailey Circus performer, was the first man to plunge over the Falls. He made his journey

in a steel barrel on July 25, 1911. Leach broke both kneecaps and fractured his jaw during the stunt and spent several months in recovery. Years later, while touring in New Zealand, he slipped on an orange peel and suffered a cut on his leg. The wound did not heal, and he lost his leg to gangrene. The infection was unabated and Leach died of complications soon after.

■ MARIA SPELTERINI

In July of 1876, Signorina Maria Spelterini, a 23-year-old Italian woman, crossed the Falls on a tightrope just 2.25 inches in diameter—with wooden baskets strapped to her feet. A week later, she crossed again, this time, while blindfolded. Later that month, she made a third attempt; this time, her feet and wrists were bound.

■ KAREL SOUCEK

Karel Soucek braved the Whirlpool Rapids in a steel barrel in June of 1977. Once he reached the Whirlpool, he became stranded. Three hours later, he was rescued by Niagara Parks Police and arrested for completing the stunt. Undeterred, Soucek braved the Horseshoe Falls in 1987 in a plastic and steel barrel he constructed for the stunt. It was heavily weighted on one end to ensure he made the plunge feet-first. As the first person to attempt the feat, he promoted himself as "the last of the Niagara Daredevils." He suffered minor cuts and bruises, was taken to the hospital, and was again arrested. His barrel was confiscated, and he was assessed a fine of just $500.00.

Soucek survived barrel trips through the Whirlpool rapids and a trip over the Horse-

shoe Falls. In 1976, he attempted to ride a moped on a high wire, but the feat was a failure. The stuntman ultimately met his death while performing a stunt at the Houston Astrodome in 1985.

Karel Soucek is buried at Drummond Hill Cemetery in Niagara Falls, Canada.

■ KIRK JONES

Kirk Jones, a 40-year-old man from Canton, Michigan, entered the waters at the Canadian Horseshoe Falls on October 22, 2003, wearing only the clothes of his back. After 8 seconds in the water and a nearly 175-foot drop, he swam to shore. Jones was treated for minor injuries at local a hospital and was released after promising to return for a court date. He was fined $2,300.00 and was banned from entering Canada.

■ NIK WALLENDA

Nik Wallenda, a well-renowned aerialist and high-wire artist, made a nationally televised walk over Niagara Falls on June 15, 2012. For the first time in his career, he was required to wear a safety harness.

Wallenda said of the stunt, "I'm facing Niagara Falls—the wind and the mist and the dark and the peregrine falcons—and I'm going to stay focused on the other side."[9]

■ ERENDIRA WALLENDA (following page)

On June 15, 2017, Erendira (Vasquez) Wallenda, wife of famed daredevil Nik Wallenda, preformed a series of aerial stunts while dangling 300 feet above the Horseshoe Falls. At approximately 8:30am, the stuntwoman was transported by helicopter from the roof of the Seneca Niagara Casino

to the brink of the Horseshoe Falls, while perched upon a metal hula-hoop-shaped device. As the helicopter hovered above the thundering waters, Erendira performed a remarkable routine, striking numerous poses—including hanging from her toes and by her teeth. The daredevil broke her husband's Iron Jaw Hang record during the event, which was held five years to the day following Nik Wallenda's tightrope walk over the Falls. Local and international media broadcast the event on TV and online.

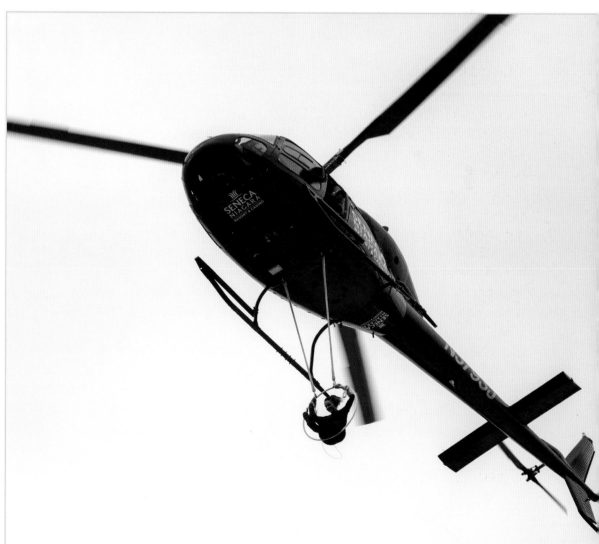

The Parks and Surrounds:
Where to Go and What to See

"If we analyze the operations of scenes of beauty upon the mind, and consider the intimate relation of the mind upon the nervous system and the whole physical economy, the action and reaction which constantly occur between bodily and mental conditions, the reinvigoration which results from such scenes is readily comprehended. . . . The enjoyment of scenery employs the mind without fatigue and yet exercises it; tranquilizes it and yet enlivens it; and thus, through the influence of the mind over the body gives the effect of refreshing rest and reinvigoration to the whole system."[10]

—Frederick Law Olmsted

5. NIAGARA FALLS, NEW YORK

Niagara Falls State Park is located in Niagara Falls, New York. The park was designed by famous landscape architect Fredrick Law Olmsted, whose personal aesthetic dictated that the park be designed to honor the natural surroundings. The park, therefore, is largely populated with towering old-growth trees, various grasses, and plants native to the Niagara region. The landscape is quite natural for the most part—though some decorative, showy plantings have been added since Olmsted's vision was originally implemented.

There's so much for visitors to do at the park—from wandering along the winding paths to take in the majesty of the lush wooded areas, to biking or jogging, to viewing the rapids and waterfalls from multiple vantage points, to taking a ride on the Maid of the Mist, or getting soaked on a Cave of the Winds tour. And that's just the beginning.

There's still more fun to be had within walking distance of the park, where you'll encounter a variety of museums, eateries, shops, and family-friendly attractions.

■ THE MAID OF THE MIST (following page)

Early in the 19th century, passengers were taxied by rowboat across the Niagara River below the Falls. By 1846, entrepreneurs decided to launch the Maid of the Mist— a sizable steamboat used to transport passengers, luggage, mail, and cargo. The first boat was large enough to transport a stagecoach and horses. Soon after, a suspension bridge was built to facilitate the crossing of the Niagara River, and the Maid of the Mist was reborn as a sightseeing venture. It has become one of the most popular attractions at the Falls.

The Maid of the Mist has carried many famous passengers, including Soviet official (later president) Mikhail Gorbachev, the Duke and Duchess of York (Prince Andrew and Sarah Ferguson), as well as Princess Diana, Prince William, and Prince Harry. Former U.S. President Jimmy Carter once enjoyed a scenic journey, as did Marilyn Monroe and Brad Pitt.

In 2012, the fate of the Maid of the Mist was uncertain. However, New York State Governor Andrew Cuomo visited Niagara

How to Get There

Niagara Falls State Park does not have a physical address. When you are planning your trip, your best bet is to enter "24 Buffalo Avenue, Niagara Falls, New York, 14303" into your map application or GPS device. When you reach this destination, simply follow the signs to park at lot 2 or lot 3. If you find that lots 2 and 3 are full, consider navigating to lot 1, which is located at 332 Prospect Street, Niagara Falls, New York, 14303 (this option is close to the Maid of the Mist and Visitor Center). Alternatively, you can drive to 10 Rainbow Boulevard, Niagara Falls, New York, 14303. This is the address of the official Niagara USA Welcome Center, where you will find additional parking.

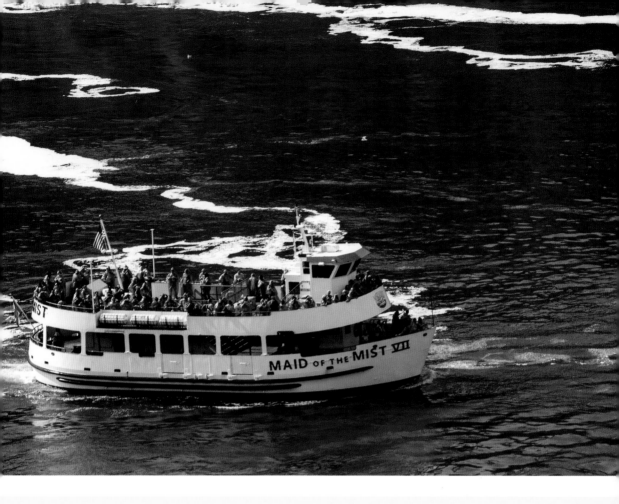

The Legend of the Maid of the Mist

The Maid of the Mist gets its name from Ongiara tribal lore. As legend has it,

"For an unknown reason, Indians were dying, and it was believed that the tribe must appease the Thunder God Hinum, who lived with his two sons in a cave behind the Falls.

At first, the Indians sent canoes laden with fruit, flowers and game over the Falls, but the dying continued. The Indians then began to sacrifice the most beautiful maiden of the tribe, who was selected once a year during a ceremonial feast. One year, Lelawala, daughter of Chief Eagle Eye, was chosen.

On the appointed day, Lelawala appeared on the river bank above the Falls, wearing a white doeskin robe with a wreath of woodland flowers in her hair. She stepped into a white birch bark canoe and plunged over the Falls to her death. Her father, heartbroken, leaped into his canoe and followed her.

Hinum's two sons caught Lelawala in their arms, and each desired her. She promised to accept the one who told her what evil was killing her people. The younger brother told her of a giant water snake that lay at the bottom of the river. Once a year, the monster snake grew hungry, and at night entered the village and poisoned the water. The snake then devoured the dead.

On spirit, Lelawala told her people to destroy the serpent. Indian braves mortally wounded the snake on his next yearly visit to the village. Returning to his lair on the river, the snake caught his head on one side of the river and his tail on the other, forming a semicircle and the brink of the Horseshoe Falls. Lelawala returned to the cave of the God Hinum, where she reigns as the Maid of the Mist."[11]

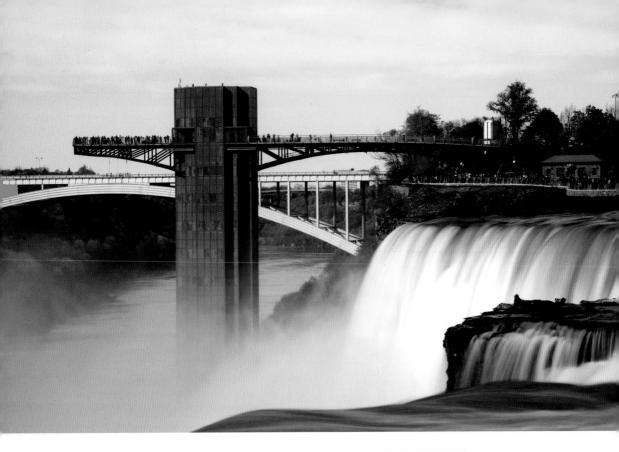

Falls, New York, to announce that an agreement made between his administration and the Maid of the Mist called for the company to pay for $32,000,000.00 in upgrades near the site of the former Schoellkopf Power Station to turn the area into off-season storage for the two boats in the fleet.

The Maid of the Mist can be boarded from 1 Prospect Point in Niagara Falls, New York. The boats depart every 15 minutes and take visitors on a 20-minute tour of the waterway, close to the base of the Falls. Spray from the Falls can be intense, and visitors are provided with a complimentary hooded poncho. People of all ages are welcome to board, and the Maid of the Mist is handicap-accessible.

◼ OBSERVATION TOWER (above)

This 230-foot overlook, located at Prospect Point, is the only U.S. location from which visitors can view the American and Bridal Veil Falls (both are pictured here) and Horseshoe Falls. High-speed elevators provide access to the gorge and to the boarding area for the Maid of the Mist.

◼ NIAGARA SCENIC TROLLEY

Take an environmentally friendly trolley on a 3-mile, 30-minute guided tour of the park. The trolleys run on natural gas and are heated in cold-weather months and air-conditioned on warm days. You can stay on the trolley for the duration of the tour or hop off to explore a variety of points of interest. Trolleys may also be booked for special events.

CAVE OF THE WINDS (below)

Are you ready to learn just what those famous yellow ponchos are for? The Cave of the Winds tour is an exhilarating and unforgettable experience. You'll descend on a series of red wooden decks and explore the area beneath the Falls. You will be drenched from head to toe by the end of the tour (hence the rain slickers), so you may choose to check in your footwear before your tour and grab a pair of the complimentary souvenir sandals the staff will offer you before the tour departs.

NIAGARA VISITOR CENTER

If you are in need of a map of the park or other key information, make a stop at the Niagara Visitor Center. The center also houses the Niagara Adventure Theater and the Niagara Falls State Park's main gift shop. Dining options are available, too. You'll have access to a café and patio grill, where you can enjoy deli sandwiches, a variety of coffees, ice cream, burgers, and more.

The Niagara Falls State Park Visitor Center also provides interactive displays and exhibits. The center is set within acres of floral gardens that have been designed to depict the Great Lakes region above the Falls, including grassy areas in the shapes of Lakes Michigan, Superior, Huron and Erie, and a walkway that follows the course of the Niagara River.

The visitors center offers a selection of official Niagara Falls souvenirs and merchandise. The money-saving Discovery Pass (see the sidebar on page 53) is also available for purchase at the center.

NIAGARA GORGE DISCOVERY CENTER

With hands-on learning for all ages, the Discovery Center includes interactive displays and a multi-screen theater showing 12,000 years' history of the Niagara River.

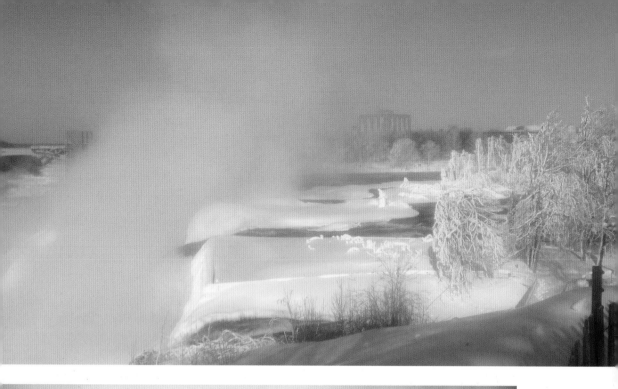

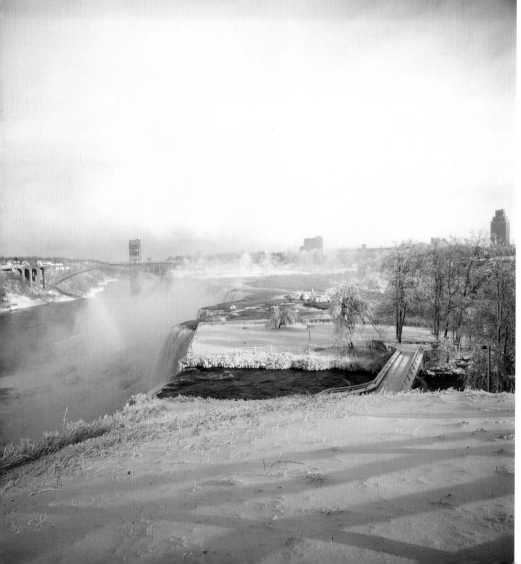

Top—Photograph
© Jerry Craig.
Bottom—Photo-
graph © Duncan
Ross.

Winter Wonderland

In the months of November through March, snowfall is likely in Niagara. Every surface is painted with glittering ice and fresh-fallen snow, and the landscape is magically transformed. The snow and frozen mist make for a slick trek, though, so shoes or boots with a substantial tread are recommended for safety.

The temperatures during the winter months range from an average high of 48° F in November to an average high of 42°F in March. Temperature lows average 31°F in November and 24°F in March. The State Park is open year-round, but some of the attractions, like the Maid of the Mist and Cave of the Winds, are closed in winter. Be sure to plan your visit accordingly.

Above—Photograph © Glenn Murray.

Bottom—Photograph of the Horseshoe Falls © Rick Warne, www.rickwarnephotography.com.

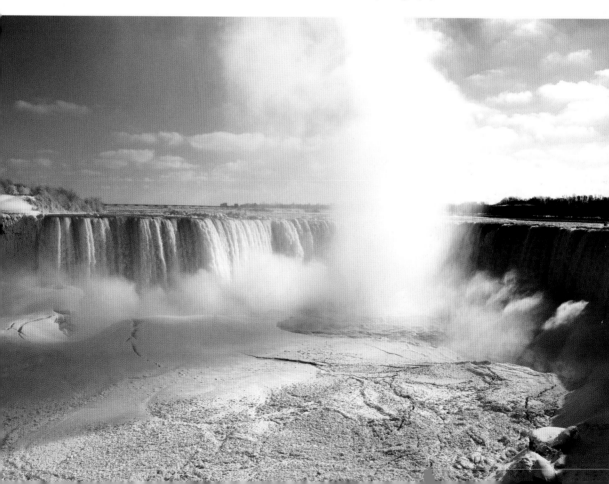

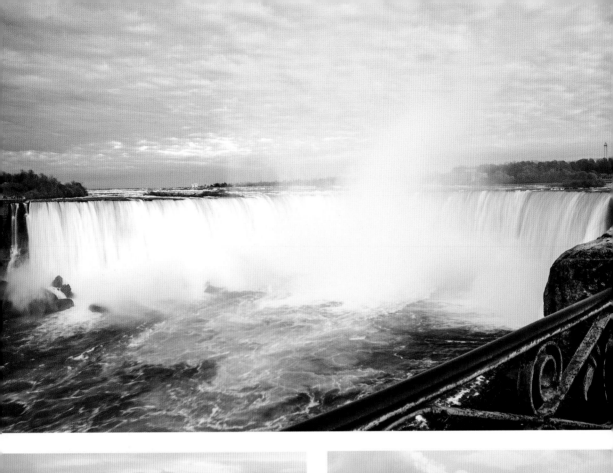

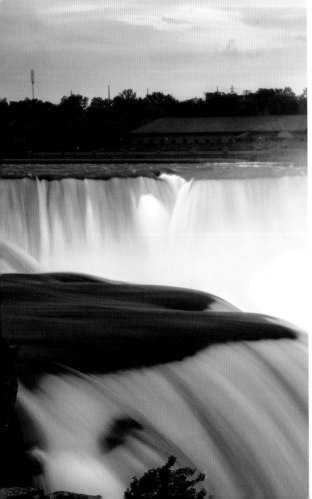

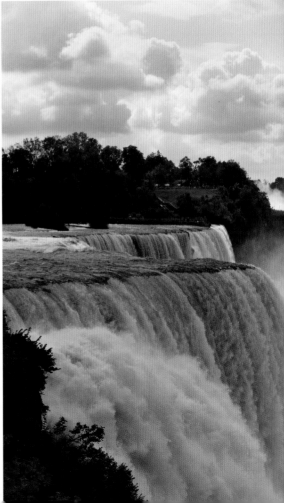

Ready for an Adventure?

To make the most of your trip to Niagara Falls, New York, consider purchasing a Discovery Pass. The pass allows users to ride the Maid of the Mist, experience the Cave of the Winds, visit the Adventure Theater, check out the Discovery Center, hop on the Niagara Scenic Trolley, and spend time marveling at the aquatic life at The Aquarium of Niagara. As of 2017, passes were $45.00 for adults and $34.00 for kids ages 6 through 12. Kids ages 5 and under are admitted to all attractions free of charge.

■ NIAGARA ADVENTURE THEATRE

The Niagara Adventure Theater is located on the lower level of the Niagara Visitor Center. When you need to take a breather, it's a great place to take in a 30-minute film that covers the history of the Falls and the heroism of some of the area's residents and visitors. The film is screened every 45 minutes.

■ AQUARIUM OF NIAGARA (below)

Located at 701 Whirlpool Street, within walking distance of the Discovery Center, the aquarium houses over 1,500 aquatic animals that represent ecosystems ranging from the Great Lakes to coral reefs.

General admission is $13.00 for adults, $11.25 for persons age 60 and over, and $9.00 for kids ages 3 through 12. Visitors 2 years old or younger are admitted free of charge.

In addition to the standard admission tickets, the aquarium offers passes that allow you to experience a touch tank ($5.00), or to visit with a seal or a Humboldt penguin ($64.99 each).

If you're not a big marine enthusiast or are trying to cram as much as possible into a short visit to Niagara Falls, New York, check out the outdoor marine enclosure to watch, free of charge, the gray seals and harbor seals at play.

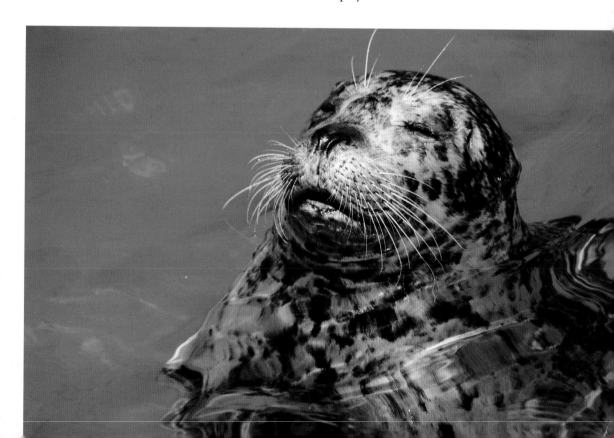

■ THIRD STREET (below and following page)

Once you've had your fill of adventure at the State Park, why not take a walk to Third Street to explore one of the many unique bars and restaurants that have opened their doors in recent years?

Power City Eatery (open for breakfast and lunch only), located at 444 Third Street, is a local favorite that offers a palate-pleasing array of sandwiches (many are made with home-cured meats, but they offer veggie options, too), all made on fresh-baked bread. The menu also features soups, salads, and desserts—and a bevy of beverages, from craft beers to specialty coffees, to juices. The eatery has a hip, sparse, industrial vibe that is uniquely pleasing, and the walls are bedecked with historic photos of the area that date back to the early 1900s. You can dine indoors or enjoy your food on a beautifully appointed patio, complete with flowering trees and umbrella tables.

The Craft Kitchen & Bar (223 Ferry Street, at the corner of Third Street) is another recent addition to Third Street. It's located roughly a block away from Power City Eatery and is a great destination to check out for a light dinner (think great burgers and fabulous warm pretzels). The Craft also offers a full bar and will tempt you with a selection of offerings from local brewers and a collection of national-market craft beers.

If you're traveling with kids, you'll want to consider stopping at The Rainforest Café. The national chain has branded itself as "a wild place to shop and eat." It is a great space with reasonably priced foods, robotic rainforest creatures, and rainforest-themed merchandise available for purchase.

Third Street Retreat is a cool retro/ vintage hidden gem of an eatery. The mom-and-pop business features a much-loved all-day breakfast, a great selection of craft beers, and an impressive pub-style menu. The staff is warm and welcoming. Hours as of this writing are Tuesday through Saturday, from 8:00am to 3:00pm. The Sunday hours are 9:00am to 3:00pm. The restaurant's hours change seasonally; they soon plan to expand their hours and offer dinner.

Nashville North is a Western-themed bar and restaurant featuring barbequed foods and live music—indoors when it's cold or raining, or on a large patio behind the bar on warmer evenings. Across the street,

you'll find another bar with a traditional feel—The Third Street Tap Room.

A bit farther down Third Street, you'll encounter Wine on Third. The venue offers its patrons a mesmerizing array of cocktails and fabulous foods with a gourmet flair. There's plenty of wall space for art and an intriguing, pleasing decor that helps make for a memorable experience.

Finally, if you've got a craving for Indian food, check out Zaika Indian Cuisine (421 Third Street). It's a favorite stop of visitors and locals alike, and the aroma from the kitchen will make your mouth water whenever you find yourself walking on Third Street.

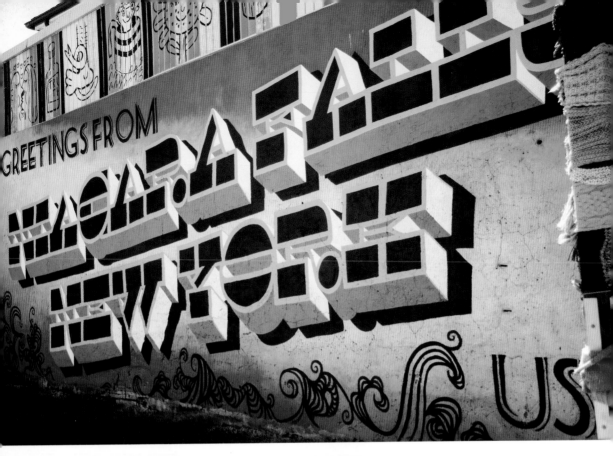

GREETINGS FROM NIAGARA FALLS NEW YORK US

Above—Artwork along upper portion of photo by Richard J. Nickel. Painting at bottom portion of photo by Rob Lynch. *Left*—Painting by Rob Lynch. *Facing page, top*—Painting by Matthew Grote.

■ ART ALLEY (previous page, this page)

Tucked away in an alley adjacent to Zaika Indian Cuisine, you will find Art Alley, which features a collection of murals made by 16 artists who hail from Niagara Falls, Toronto, Cincinnati, and as far away as Virginia. The walls come alive with a collection of student artwork and professional work. The project is curated by a local art teacher and professional artist, Rob Lynch, and was co-created by Lynch and Niagara Falls Director of Community Development, Seth Piccirillo. Together, Lynch, Piccirillo, and the team of artists have transformed what once was a blighted property into a fun, offbeat destination designed to attract tourists and point to the positivity and optimism that local businesses and residents feel for their city.

One thing is for certain: Art Alley is a great place to wander, study the thought-provoking work, and to take a few selfies. Also, at the mouth of the alley, you'll find an artfully decorated piano meant for pedestrians and visitors to play. The impromptu concerts are a joy.

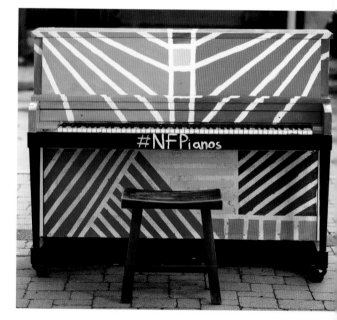

■ OLD FALLS STREET (below)

The three-block stretch of Old Falls Street is a veritable welcome center to the Niagara Falls State Park area. It is home to an enticing array of places to discover, from gift shops to eateries—including food trucks that operate seasonally, like Mother Cluckers, which specializes in peri-peri chicken, and Kathi Roll, an Indian street food vendor with menu options that are out of this world and surprisingly inexpensive; American favorites like pizza and burgers; and fine dining at the impressive Savor, located on the first floor of the Niagara Falls Culinary Institute.

Between Memorial Day and Labor Day, Old Falls Street is home to free outdoor concerts on Friday evenings and movies on Thursday nights. A Free Family Fun event is held on Saturday afternoons.

A great option for kids—and adults who are kids at heart—is to visit one of two areas set up with free outdoor games, including Ping-Pong tables, a bean-bag toss, a giant chess board, a super-sized checkers game, and an oversized Connect Four game. You can also indulge in hop scotch and play an oversized Jenga game.

These play areas also provide brightly colored café tables and chairs, and Adirondack chairs where adults can kick back while the kids play.

Before you retire your Ping-Pong paddles and leave the play place, wander over to take in the wonderful Lego-type bulletin boards or chalk boards where you can view messages left by people from all over the world who have played there before you.

Another Old Falls Street perk is that visitors can take advantage of the free, hop on/hop off Discover Niagara Shuttle, which brings guests to 15 neighboring attractions from Niagara Falls to Youngstown, New York—home to the historic Fort Niagara. See the sidebar on the following page for shuttle information.

■ SMOKIN JOE'S NATIVE CENTER (right)

There's a rich Native American history in the Niagara region, and Smokin Joe's Native Center is a great place to go to learn more about it. The center features exhibits of indigenous art, teepees, statues, murals, dioramas, and more. When you visit the gift shop, you'll find native-made pottery, dreamcatchers, jewelry, and other merchandise that honors the native tribes.

■ IT'S ALL FUN AND GAMES

There are two arcades that you can visit if you're looking for an opportunity to let the kids blow off a little steam while you relax and perhaps do some thinking about what the rest of your visit has in store. Check out At the Falls Arcade (300 Third Street) or Great American Arcade (114 Buffalo Avenue). If you're looking for a little more action, head to the Niagara Adventure Park (427 First Street) for zip line rides, bungee jumping, tubing, and other adventures.

■ A HAUNTING

The Haunted House of Wax (23 Rainbow Boulevard) is a quirky, ghoulish, and somewhat grotesque haunted house attraction. It doesn't take too long to make your way through the establishment—the average time spent is about 10 minutes—but it's fun and inexpensive, too. Note that the Haunted House of Wax is open seasonally.

The Discover Niagara Shuttle

Whether you have a vehicle of your own or are fully reliant on using public transportation to get around the Niagara region, you'll be happy to note that you can avoid the hassles of getting directions to popular destinations and finding parking there by taking a ride on the Discover Niagara Shuttle. The shuttle stops at many free parking lots—including the Aquarium, Whirlpool State Park, Old Fort Niagara, and the Gorge Discovery Center.

There are four shuttles in the fleet, and they run from 9:00am to 6:00pm Sunday through Thursday and 9:00am to 12:00am Friday and Saturday. The last shuttle visits Youngstown at about 5:30pm Sunday through Thursday and 11:30pm Friday and Saturday, headed to Niagara Falls. You can download the Discover Niagara app on your smartphone to check the schedule and pickup/drop-off points.

◼ SENECA NIAGARA CASINO & RESORT

It's a short walk from Third Street to the Seneca Niagara Casino & Resort, where you can indulge yourself in slot and table games or treat yourself to dinner at one of a host of restaurants. There's a steakhouse, an upscale Italian eatery, Three Sisters Café (for Native American cuisine), an Asian restaurant named Koi, and more. There are several shops inside, as well as a nightclub on the premises. Indoor concerts by national music acts are well-attended, as are the (weather-permitting) outdoor concerts.

◼ ACCOMMODATIONS

There are numerous hotels and motels to choose from in Niagara Falls, New York. The national, trusted hotel chains—The Sheraton, Quality Inn, Hampton Inn, and Holiday Inn, for example—are readily available, as are several mom-and-pop motels, which you'll find on Niagara Falls Boulevard, 5 miles or so from the Falls. If you plan to visit the Seneca Niagara Casino & Resort, spending a night or two there might be a good choice. However, if you're looking for something more memorable, there are some interesting, historic alternatives.

Located at 222 First Street, The Giacomo is both close to Niagara Falls State Park (it's an eight-minute walk) and luxurious. The boutique hotel has received rave reviews for its accommodations, which includes the Skye View Room on the building's 19th floor, a full lounge, gym, and free Wi-Fi. Guests also receive a complimentary breakfast buffet.

The Giacomo opened its doors in 2010. It is housed in a gorgeous Art Deco structure (formerly the United Office Building), which was built in 1929 and is listed on the National Register of Historic Places. The exterior sports a Mayan revival design motif, and the detail is a wonder to behold.

Guest rooms include a desk, 32-inch flat-screen TV, walk-in shower, and luxurious bedding. Select rooms are available with a spa bath or stonework electric fireplace. Another perk? If you're traveling with a four-legged friend, you'll be pleased to know that pets are allowed ($25.00 per night, per pet. They allow a maximum of two pets per room). Prices start at $169.00.

Another top-rated option is the historic and impressive English Tudor-style Red Coach Inn, which opened in 1923. The Inn is located at 2 Buffalo Avenue and is an easy five-minute walk to and from the Falls. The original owners' goal in establishing the Inn was to replicate the atmosphere and style of the historic Bell Inn in Finedon, England. Today, the Red Coach Inn offers great dining in a space that feels a lot like an old English dining room, complete with an impressive bar. Prices start at $185.00 per night.

If a bed and breakfast is more to your liking, check out the beautifully appointed Hillcrest Inn (1 Hillcrest Street; $139.00 to $193.00 per night), the handsomely restored 1913 Arts and Crafts property called Park Place Bed and Breakfast (740 Park Place; $129.00 to $169.00 per night), or the Victorian-style Rainbow House Bed and Breakfast and Wedding Chapel (423 First Street; rates vary depending on the season).

Finally, Gorge View, located at 723 Third Street, not far from The Aquarium of

Niagara, is a great option for frugal visitors, students, and backpackers. Beds start at $30.00 per night. Private rooms, female-only dorms, and mixed dorms are available. A fully equipped kitchen and free shuttle service are notable perks to lodging at the Gorge View.

■ A LITTLE FARTHER OUT

The Niagara region is steeped in military history. In the mid 18th century, there were two forts located along the eastern bank of the Niagara River, in what is now the city of Niagara Falls. In 1750, French traders began construction of what was alternately called "Fort du Portage" or "Little Fort Niagara." Sieur de Chabert (a.k.a. Chabert Joncaire) supervised the construction of a two-story log barracks, situated just below the fort—complete with a nearly 31-foot-high stone chimney that allowed for the use of a fireplace on each of the barrack's floors.

Nine years after the fort was built, British forces began to encroach. The men of Fort du Portage set fire to the fort and barracks and made their way to Fort Niagara. When the fires died down, all that remained was the towering stone chimney (right).

The British built Fort Schlosser, which was occupied by American troops during the War of 1812, just to the east of the site of Fort du Portage. The men constructed a large residence and attached it to the Old Stone Chimney.

Today, the great chimney still stands. It is presently located by the upper Niagara River, alongside the Robert Moses Parkway. Fort Schlosser no longer remains. It was burned to the ground by British troops in 1813, in retaliation for the American troops' burning of Newark (now known as Niagara-on-the-Lake).[12] A historical marker indicates Fort Schlosser's footprint.

The Historic Oakwood Cemetery (1763 Portage Road) was established in 1852, following the donation of land by Lavinia Porter, the daughter of Judge Augustus Porter, who was one of the founders of Niagara Falls and a major Niagara landowner. The cemetery's landscape is based by on a 1882 drawing created by the city's former civil engineer, Drake Whitney.

On the grounds, you'll find a marble mausoleum with soaring stone columns and a Louis Comfort Tiffany window. Impressive bronze doors allow entry into a chapel within the structure.

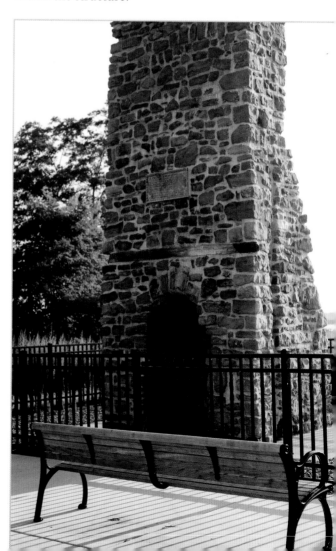

Many of the families who helped to shape Niagara Falls are buried in the cemetery. You'll also be able to visit the graves of daredevils Annie Edson Taylor and Carlisle D. Graham, Homan Walsh (a child who flew his kite across the gorge to get the cable for the first suspension bridge across the river), and "Francis the Hermit," a reclusive Englishman who built a cabin on Goat Island, lived in isolation for two years writing and painting, and whose body was later discovered in the river below the Falls.

Main Street, Niagara Falls, has seen better days. Once the hub of activity in the city and home to thriving businesses, a downturn in the economy has given the area a black eye. It's interesting to see, though, to get a feel for the city's history, and a couple of businesses that remain that are sure to impress.

Bibliophiles will fall in love with The Book Corner (1801 Main Street), a massive independent bookstore. The basement and upper floor offer used books, while the

main floor provides visitors the opportunity to browse local interest books, mass market titles, children's books, and more. The upper floor, many years ago, was home to a bowling alley. Now, the space is filled with books, instruments that visitors can play, and furniture on which to lounge. This is not your trendy bookstore/café. You can't get food here (in fact, there is no public restroom, either). The proprietor is extremely knowledgeable; if you have questions about rare books or the latest in popular fiction, Jeff Morrow is your go-to guy.

The Earl W. Brydges Library (1425 Main Street), designed by noted architect Paul Rudolph, is another great destination for book lovers. The huge library

houses a local history room which will interest tourists, and its unique Brutalist architecture is sure to leave a lasting impression.

Another business anchor on Main Street is the Rapids Theater (1711 Main Street), an indoor all-ages concert venue and events center. National acts perform there regularly. Check out their website at www.rapids theater.com for concert and event listings.

Prophet Isaiah's Second Coming House (1308 Ontario Street) is located just a couple of blocks from The Book Corner. Is it a church? Nope. A place of worship? Kind of. It is a private home painstakingly decorated with a dazzling, colorful display of religiously significant folk-art-esque motifs. Every square inch of the home's exterior is covered with bright, dimensional wooden pieces and further embellished with plastic flowers. It's something to see. When you do, you'll never forget it.

The Niagara Arts & Cultural Center (NACC) is a great find for art lovers. As the largest multi-arts center in upstate New York, it is home to 75 artists and arts groups and contains over 60 artist studios, three public galleries, multiple private galleries, three theaters, a radio station, a sound stage/movie production facility, and a café and gift shop. It's a stone's throw from the Falls; visit at 1201 Pine Avenue.

The images on the right are from a NACC exhibit called the Art of Fashion, which featured wearable art, photography, and fashion-inspired paintings.

The Niagara Gorge, located on Whirlpool Street, is a must-see destination for nature lovers, hikers, cyclists, and adventurers. The 6.8-mile site offers scenic trails, rated from easy to difficult. You'll observe wildlife, sedimentary rock formations, and explore native trees and wildflowers while hiking these trails.

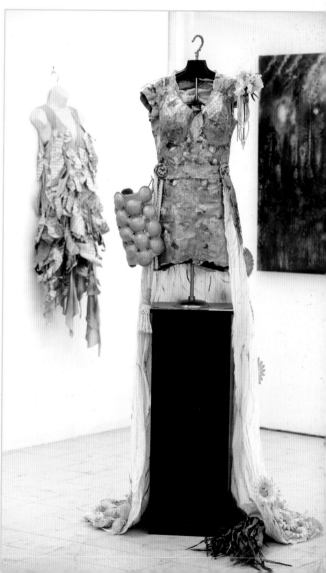

The Bakery Restaurant & Lounge (3004 Niagara Street) is a cozy and quirky place to grab some dinner. The establishment has a long history in Niagara Falls and features primarily steak, chicken, seafood, ribs, and pasta dishes—though vegetarian, vegan, and gluten-free options are also available. Back in the day when landlines were a staple, telephones were located at the restaurant's booths so patrons could place calls to other tables and socialize with other customers.

If you are in need of some retail therapy, consider taking a ride uptown to the Fashion Outlets of Niagara, located at 1900 Military Road. The outlet mall boasts over 200 stores, a currency exchange center, food court, stroller rentals, and complimentary wheelchairs. Shops include Saks Fifth Avenue, Old Navy, American Eagle Outfitters, Adidas, Calvin Klein, Coach, Brooks Brothers, Burberry, Banana Republic, Polo Ralph Lauren, and more. The mall is open from 10:00am to 9:00pm Monday through Saturday and 10:00am to 6:00pm on Sundays.

If you work up an appetite while you're shopping, you'll be happy to know that there are many eateries within a couple

Made in Niagara

RegalTip drumsticks are manufactured in Niagara Falls, New York. Johnny Ryan sodas, established in 1935, made with pure cane sugar, and widely available at eateries and grocery stores, is made in town, too. Grab a bottle when you crave some refreshment.

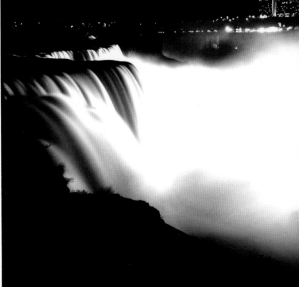

Photo of the rapids (left) and the American and Bridal Veil Falls (right) from Prospect Point, © Robert A. Schultz.

minutes' drive from the mall that will tickle your taste buds and leave you happily sated.

The Griffon Gastropub (2470 Military Road) offers an eclectic array of good eats, including the chicken and waffle sandwich, Kona coffee hangar steak, crab legs and other seafood, a slew of handmade burgers with inventive toppings, and an absolutely tantalizing beer menu. The pub is extremely popular with locals and travelers, so making reservations is recommended.

My hands-down favorite place to grab a bite is Buzzy's New York Style Pizza (7617 Niagara Falls Boulevard). This family-friendly restaurant offers pickup/delivery and two dining rooms. The pizza is out of this world; the crust is soft and slightly sweet—unlike any other I've enjoyed—and they're not shy about adding oregano. Order a side of Buffalo Wings (locals simply call them "wings"), too. They are a dietary staple in the Buffalo/Niagara region.

Niagara Falls natives who come home for a visit will tell you that there are two places they head to in order to satisfy their cravings and pique their sense memories: Di Camillo Italian Bakery and Viola's Submarine House.

Di Camillo Italian Bakery (7927 Niagara Falls Boulevard) has a long history in Niagara Falls, and there are four locations in the Niagara region (and one in Williamsville, in Erie County). The scent that greets you when you enter the bakery is divine, and their Italian bread is superb. They also carry fresh-baked cakes, pastries, cannoli, biscotti, and more. Treat yourself. You'll be glad.

Viola's Submarine House (1539 Military Road and downtown, at 1717 Elmwood Avenue; cash only) is another long-standing favorite. Their steak-and-cheese sub is legendary, but they have a pretty extensive menu that offers something for everyone.

This is not a sit-down restaurant with wait staff. Rather, you order at a window and pick up your food to go. There are a few booths to accommodate customers, but they quickly fill up.

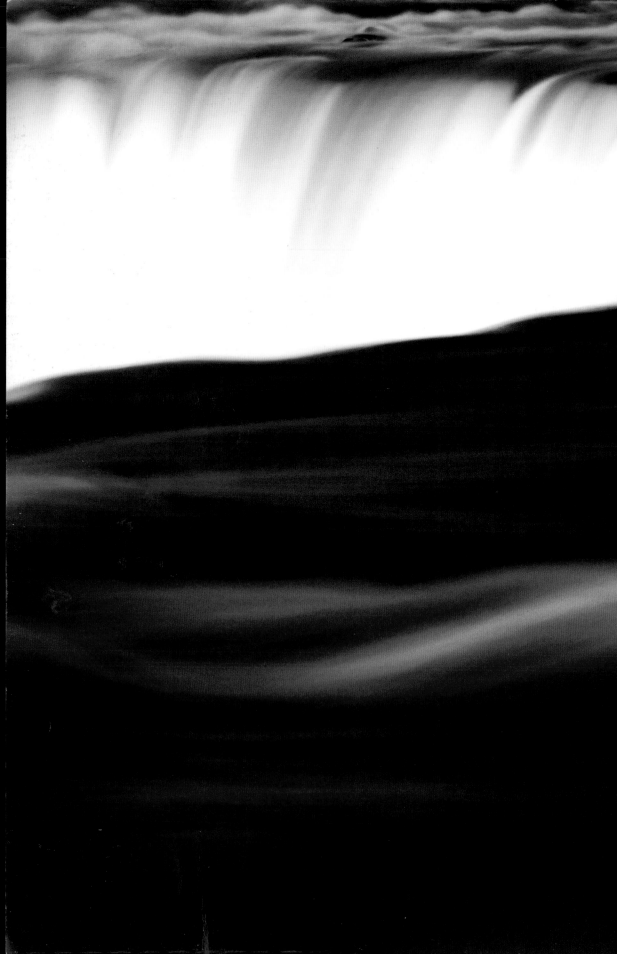

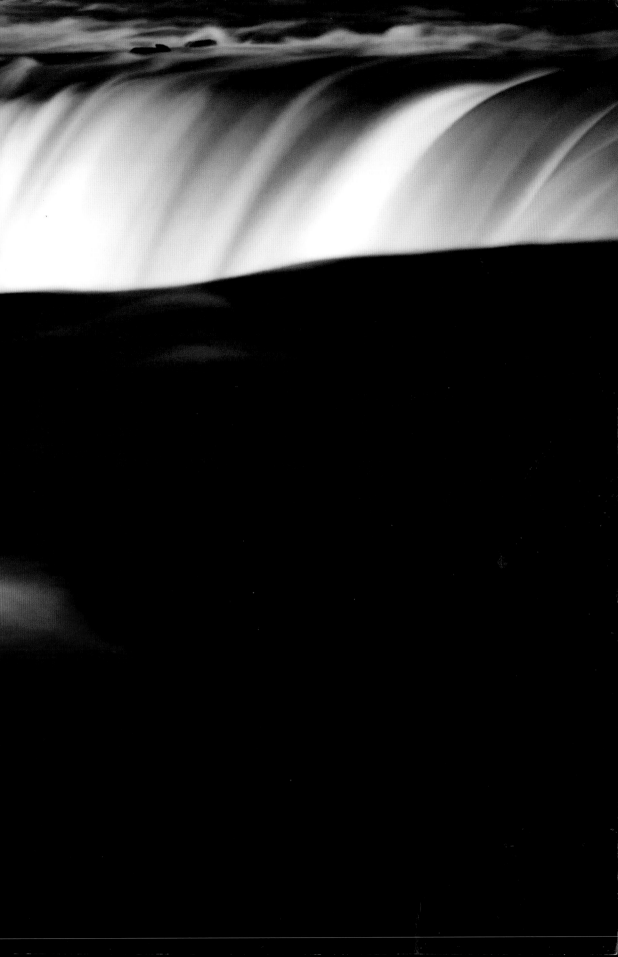

Helpful Resources

Note: This section is comprised of some of the best-reviewed and most unique businesses. It is not a comprehensive list of the region's offerings. Check www.yelp.com or www.tripadvisor .com for additional options in the following categories.

ACCOMMODATIONS
- **The Giacomo**, 222 First St., Niagara Falls, NY 14303, www.theGiacomo.com
- **Gorge View**, 723 Third St., Niagara Falls, NY 14301, www.gorgeview.net
- **Hillcrest Inn**, 1 Hillcrest St., Niagara Falls, NY 14303, www.hillcrestniagara.com
- **Park Place Bed and Breakfast and Wedding Chapel**, 740 Park Pl., Niagara Falls, NY 14301, www.parkplacebb.com
- **Rainbow House Bed and Breakfast and Wedding Chapel**, 423 First Street, Niagara Falls, NY 14303, www.rainbowhousebb.com
- **Red Coach Inn**, 2 Buffalo Ave., Niagara Falls, NY 14303, www.redcoach.com

FAMILY FUN
- **Aquarium of Niagara**, 701 Whirlpool St., Niagara Falls, NY 14301 www.aquariumofniagara.org
- **Cave of the Winds**, Goat Island, Niagara Falls, NY 14301, www.niagarafallslive.com
- **Devil's Hole State Park**, Robert Moses Pkwy., Niagara Falls, NY 14305 http://nyfalls.com/niagara-falls/devils-hole
- **The Great American Arcade**, 114 Buffalo Ave, Niagara Falls, NY 14303 www.greatamericanarcade.com
- **Maid of the Mist**, 151 Buffalo Ave., Niagara Falls, NY 14303, www.maidofthemist.com
- **Niagara Arts and Cultural Center**, 1201 Pine Ave., Niagara Falls, NY 14301 www.thenacc.org
- **Niagara Falls Adventure Park**, 427 First St., Niagara Falls, NY 14303 www.nfadventurepark.com
- **The Niagara Gorge Discovery Museum**, Schoellkopf Geological Museum, Niagara Reservation State Park, Niagara Falls, NY 14304, www.niagarafallslive.com/niagara_gorge_ discovery_center.htm
- **Rainbow Air Helicopter Tours**, 454 Main St., Niagara Falls, NY 14301 www.rainbowairinc.com
- **Smokin Joe's Native Center**, 333 First St., Niagara Falls, NY 14303 www.sjnativecenter.com
- **Third Street Art Alley**, 425 Third St., Niagara Falls, NY 14301, www.facebook.com/ artalleynf

NEWSPAPERS
Niagara Gazette, www.niagara-gazette.com
Niagara Falls Reporter, www.niagarafallsreporter.com

NIGHTLIFE

Note: The legal drinking age is 21 in New York State.

- **The Craft Kitchen and Bar**, 223 Ferry Ave., Niagara Falls, NY 14301, www.thecraftnf.com
- **Legends Bar & Grill**, 240 First St., Niagara Falls, NY 14303, www.qualityniagarafalls.com
- **The Rapids Theatre**, 1711 Main St., Niagara Falls, NY 14305, www.rapidstheatre.com
- **Seneca Niagara Resort & Casino**, 310 Fourth St., Niagara Falls, NY 14303
 www.senecaniagaracasino.com
- **The Third Street Tap Room**, 439 Third St., Niagara Falls, NY 14301
 www.thirdsttaproom.com
- **Wine on Third**, 501 Third St., Niagara Falls, NY 14301, www.wineonthird.com

RELIGIOUS PLACES OF INTERET

Prophet Isaiah's Second Coming House, 1308 Ontario Ave., Niagara Falls, NY 14305

RESTAURANTS—NIAGARA FALLS, NEW YORK

- **The Bakery Restaurant and Lounge**, 3004 Niagara St., Niagara Falls, NY 14303
 www.bakeryrestaurantandlounge.com
- **Buzzy's New York Style Pizza**, 7617 Niagara Falls Blvd., Niagara Falls, NY 14304
 www.buzzyspizza.com
- **The Craft Kitchen & Bar**, 223 Ferry Ave, Niagara Falls, NY 14301, www.thecraftnf.com
- **The Griffon Gastropub**, 2470 Military Rd, Niagara Falls, NY 14304
 www.griffongastropub.com
- **La Galera**, 8215 Niagara Falls Blvd., Niagara Falls, NY 14304
 www.lagaleramexicanrestaurant.com
- **Power City Eatery**, 444 Third St., Niagara Falls, NY 14301, www.powercityeatery.com
- **Savor**, 28 Old Falls St., Niagara Falls, NY 14303, www.nfculinary.org
- **Third Street Retreat**, 250 Rainbow Blvd., Niagara Falls, NY 14303
 www.thirdstreetretreat.com
- **Viola's Submarine House**, 1539 Military Rd., Niagara Falls, NY 14304, 716.297.3550
- **Wine on Third**, 501 Third St., Niagara Falls, NY 14301, www.wineonthird.com
- **Zaika Indian Cuisine**, 421 Third St., Niagara Falls, NY 14301, www.anindianzaika.com

SHOPPING

- **The Book Corner**, 1801 Main St., Niagara Falls, NY 14305, www.fallsbookcorner.com
- **Fashion Outlets of Niagara**, 1900 Military Rd., Niagara Falls, NY 14304
 www.fashionoutletsniagara.com
- **Made in America Store**, 360 Rainbow Blvd., Niagara Falls, NY 14303
 www.madeinamericastore.com
- **Three Sisters Trading Post**, 454 Main St, Niagara Falls, NY 14301
 www.threesisterstradingpost.com

TRANSPORTATION

- **Discover Niagara Shuttle Service**, http://discoverniagarashuttle.com

6. NIAGARA FALLS, CANADA

■ **QUEEN VICTORIA PARK** (below and following page) When you cross the border from Niagara Falls, New York, to Niagara Falls, Ontario, Canada, you'll find yourself in the lovely Queen Victoria Park. This park is quite different from the Niagara Falls State Park in the United States. It is well-groomed and uniquely impressive.

Queen Victoria Park features a collection of unique plants that are native to the Niagara region, plus others from farther reaches that were chosen to beautify the landscape.

As you wander through the park beside the American and Bridal Veil Falls and the Canadian Horseshoe Falls, you will find a rock garden, hanging baskets, a hybrid tea rose garden, and a series of attractive flowering bed displays. Park benches are plentiful, and well-manicured lawns are perfect spots to relax or take some photos.

Within the park, you'll also find access to a number of adventures that will make your visit memorable. Some of these, though the names differ, mirror the experiences outlined in the section on Niagara Falls, New York. Other attractions are unique to the Niagara Falls, Canada, experience.

Let's take a look.

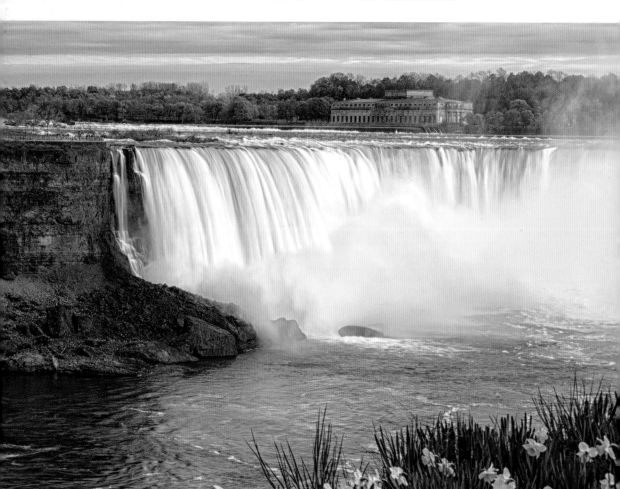

■ A CANADIAN CRUISE (below)

Take a ride on a catamaran and journey past the American Falls, Bridal Veil Falls, and into the heart of the Horseshoe Falls for a good soaking (fortunately, the staff will provide hooded raincoats). Consider taking the Falls Fireworks Cruise or Falls Illumination Cruise. Each are 40 minutes, versus the Voyage to the Falls Boat Ride, a daytime cruise that lasts 20 minutes. This ride is handicap-accessible and can be booked for private events and weddings. Tickets can be purchased for the boat tour as a stand-alone experience and are also included in the Adventure Pass.

■ JOURNEY BEHIND THE FALLS

Take a journey below and behind the heart of Niagara and get drenched by the mist of the Horseshoe Falls, as the water begins to plummet 13 stories above. You'll watch as one-fifth of the world's fresh-water

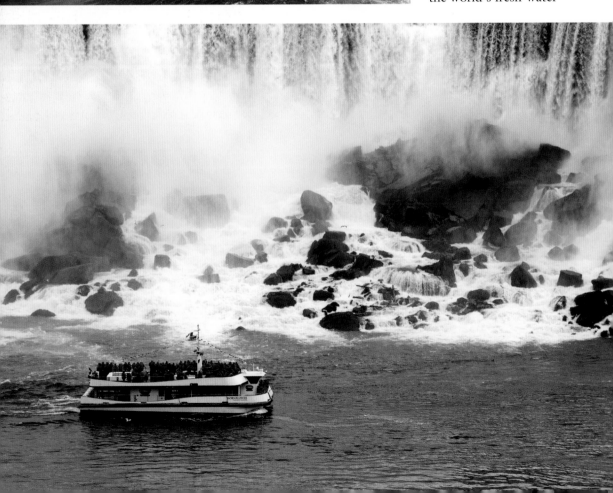

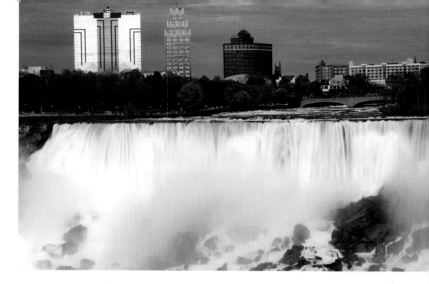

supply comes crashing down into the basin below. Literature published about the adventure claims "During summer daylight hours, over 2,800 cubic meters of water thunders over the brink every second, traveling 65 kilometers per hour."[13]

Journey Behind the Falls begins at the brink of the Canadian Horseshoe Falls, in the Table Rock Welcome Centre. Upon admission, guests will take an elevator down 150 feet/45 meters to tunnels leading to the Cataract Portal and Great Falls Portal, located one-third of the way behind the massive sheet of water.

Visitors can walk along the upper and lower observation decks at the foot of the Falls and are provided with souvenir rain ponchos

The Niagara Falls Adventure Pass

The purchase of a Classic Niagara Falls Adventure Pass allows you admission to the top Niagara Falls, Canada, attractions: Hornblower Niagara Cruises, Journey Behind the Falls, Niagara's Fury, and White Water Walk. You'll also receive a two-day pass for the WEGO, a hop-on, hop-off transportation system that allows you to travel between your hotel and the listed attractions. These tickets can be had for $55.00 for persons 13 years of age and older or $37.00 for kids age 6 through 12. (Prices are subject to change.) There are two other Adventure Pass packages to select from, too: The Adventure Pass Nature allows for admission to Hornblower Niagara Cruises, the Whirlpool Aero Car, the Butterfly Conservatory, Floral Showhouse, and also includes a two-day WEGO access pass. The cost is the same as is listed for the Classic Pass. The final option is the Adventure Pass Plus. It's perfect for visitors with a little more stamina. These tickets cost $90.00 for adults and $59.00 for kids ages 6 through 12. This pass provides access to Hornblower Niagara Cruises, Journey Behind the Falls, Whirlpool Aero Car, White Water Walk, Butterfly Conservatory, Floral Showhouse, Niagara's Fury, Falls Incline Railway, and four Heritage Sites. The pass also grants the buyer two-day WEGO access.

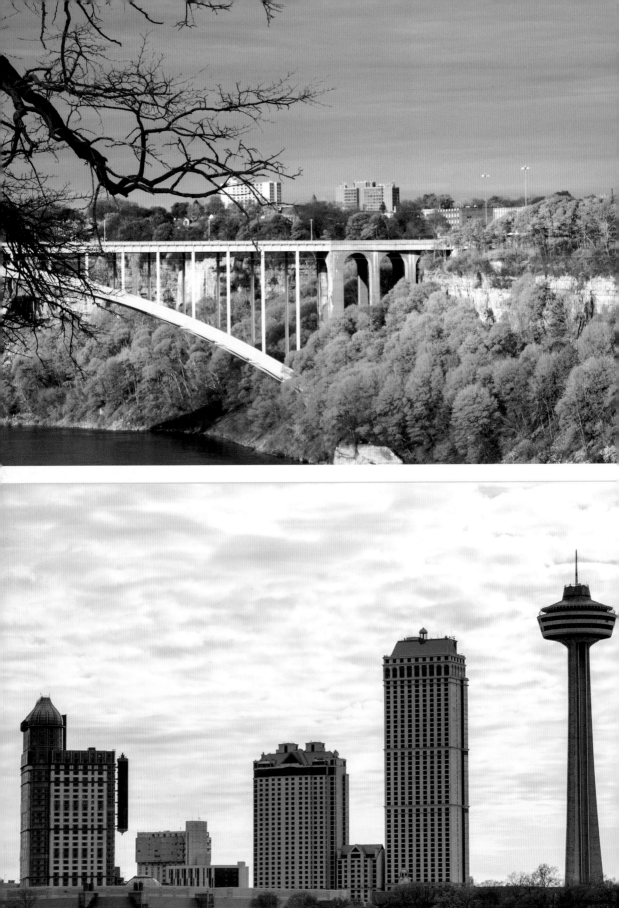

to help keep them dry. *Note:* The lower observation deck is closed during the winter months, but the upper deck, tunnels, and viewing portals are open year-round.

■ NIAGARA'S FURY

Located at 6650 Niagara Falls Parkway is Niagara's Fury, a 4D, 360-degree theater where visitors can relax and relive history in a multi-sensory theater. Water bubbles and sprays as visitors travel downriver, while snow falls all around and simulates the last Ice Age. There is a moving platform under attendees' feet that helps to enhance the viewers' perception of the power of nature. Niagara's Fury is a great starting point for every visitor to the Niagara area.

■ WHITEWATER WALK

If you prefer to experience your vacation adventures on your own terms, the Whitewater Walk is for you. When you sign up for the Whitewater Walk, you can learn about the raw power and peril of the Niagara River's class-6 white-water rapids as you walk along numerous viewing platforms along the river's edge.

This self-guided tour includes many stories about the geology of the Niagara Gorge and the plant and animal life you may encounter during your visit to the Niagara region.

■ FIREWORKS

Ready for an unforgettable experience? Niagara Parks in Ontario, Canada, plays host to a display of fireworks—free of charge. Though the display may be canceled due to inclement weather, including strong winds, the odds are pretty good that you can view

the show at 10:00pm, Monday through Friday, from mid June through early September. For a detailed schedule, please visit: www.niagaraparks.com/niagara-falls-attractions/niagara-falls-fireworks.html.

If you arrive early, you may be lucky enough to stake out a great spot in Queen Victoria Park. Live entertainment is available while the Coca Cola Concert Series is in session, typically every Friday and Sunday evening, as well as on holidays, from late May through early September. You can also grab a bite to eat at one of the many local restaurants or spend a little time shopping before the fireworks start. Parking is available at the Falls Parking Lot, which is located across from the Table Rock Welcome Centre.

■ THE SKYLON TOWER (left)

The memorable Skylon Tower opened to the public in 1964. The multi-window structure at the top contains a revolving dining room, from which visitors can get a spectacular view of the Falls—while they enjoy an upscale meal. The "Ride to the Top" indoor/outdoor observation elevators (locals call them "the yellow bugs") are crowd-pleasing, too. The tower contains a Family Fun Center, a 3D/4D theater in which the film *Legends of the Falls* is shown, and multiple shops. The Skylon is a must-see destination for every visitor to Niagara.

■ CASINOS

There are two casinos located in Niagara Falls, Canada. Check out the Niagara Fallsview Casino Resort (6380 Fallsview Boulevard) or Casino Niagara (5705 Falls Avenue) for a first-class gambling, entertainment, and dining experience. May Lady Luck shine on you.

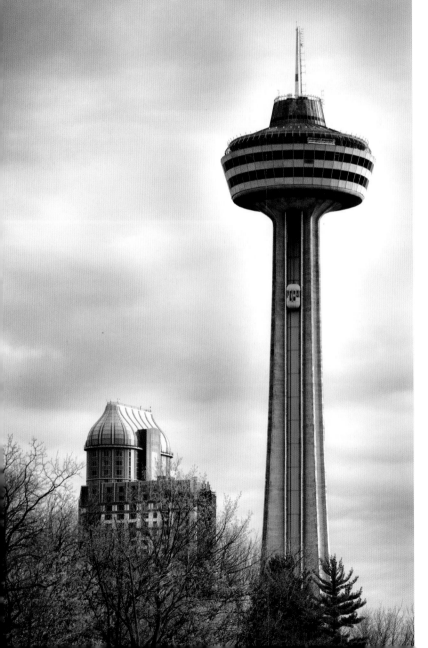

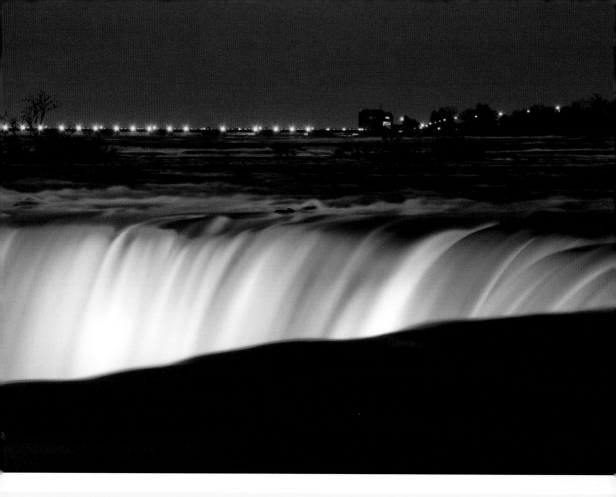

Illumination Schedule

January 1–31, 5:00pm to 12:00am
February 1–28, 6:30pm to 12:00am
March 1–11, 7:00pm to 12:00am
March 12–31, 8:30pm to 12:00am
April 1–30, 8:00pm to 1:00am
May 1–14, 8:15pm to 2:00am
May 15–31, 8:30pm to 2:00am
June 1–July 22, 8:45pm to 2:00am

July 23–August 15, 8:15pm to 2:00am
August 16–31, 7:45pm to 2:00am
September 1–19, 7:15pm to 2:00am
September 20–30, 6:45pm to 2:00am
October 1–15, 6:30pm to 1:00am
October 16–November 4, 6:00pm to 1:00am
November 5–December 30, 4:30pm to 12:00am
December 31, 4:30pm to 2:00am

◼ NIAGARA AT NIGHT (above)

Sure, the Canadian Horseshoe Falls and the American and Bridal Veil Falls are beautiful at any time of day, but at night, the magic is amplified. The "night light" spectacle can be enjoyed year-round, but the start and end times change from month to month. See the Illumination Schedule above to ensure that you're able to see the awe-inspiring show during your visit.

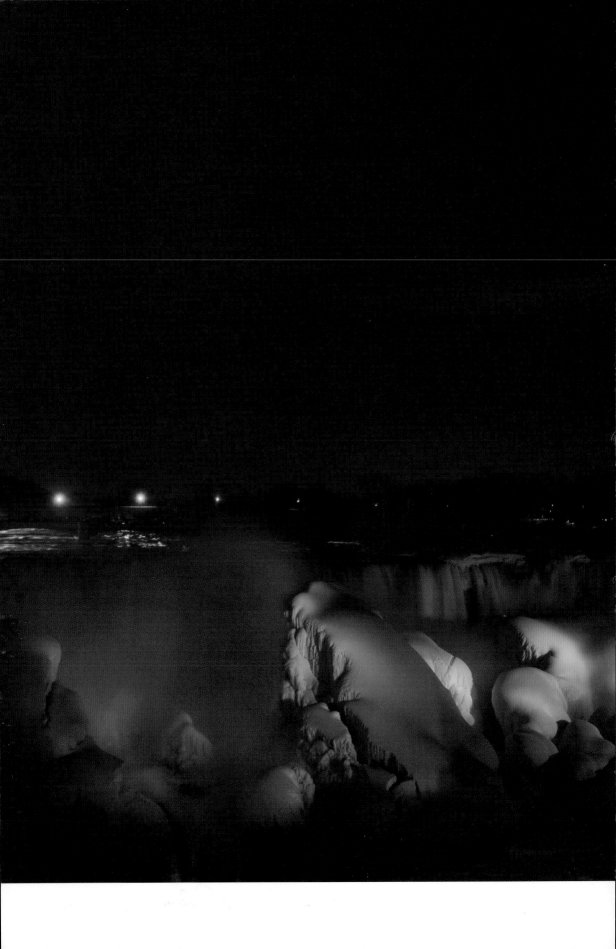

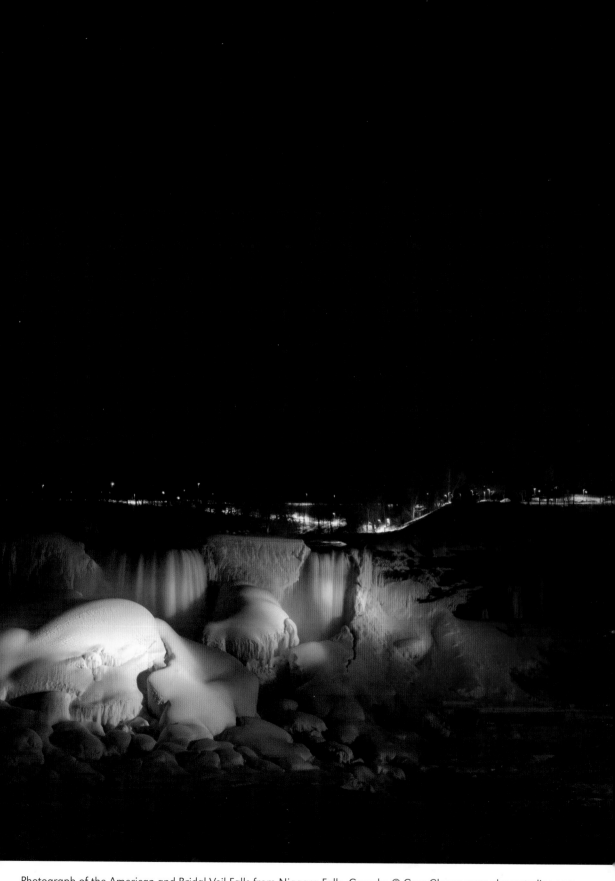

Photograph of the American and Bridal Veil Falls from Niagara Falls, Canada. © Gary Glaser, www.glaserstudios.com.

THE UTTERLY ENTERTAINING CLIFTON HILL

There's no doubt about it: Clifton Hill is a blast. The aptly named destination offers a head-spinning array of activities and lots of family fun—but be prepared to exert some serious energy while you trek up and down the street, which is situated on a steep incline. On Clifton Hill, you'll encounter arcades, haunted-house attractions, themed mini-golf courses, bowling, lots of quick eats, and a shooting range, to name just a few of the highlights.

You can purchase a Clifton Hill Fun Pass if you're ready to devote an appreciative amount of time to having some serious fun. With purchase (ticket prices start at just over $23.00), you'll get a ride on the Niagara Sky Wheel, Wild West Coaster, and Ghost Blasters Dark Ride. You can also visit the Movieland Wax Museum and play a game of mini golf at either Dinosaur Adventure Golf or Wizard's Golf.

The Niagara Sky Wheel (shown under construction, above) is an impressive Ferris wheel that will offer you a view of the Falls from a height of 175 feet. The ride's gondolas (or "cars") are fully enclosed and climate controlled so that you can enjoy a breathtaking view of the three Falls and Queen Victoria Park, rain or shine.

Dinosaur Adventure Golf offers two mini-golf courses. As you putt, you'll wander along paths and mingle with life-size dinosaurs. Recordings emit grunts and growls that are sure to make you smile. It's a good time, and a great family activity. The unique courses are challenging for both novice and experienced golfers.

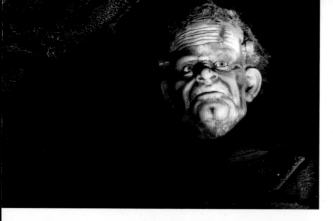

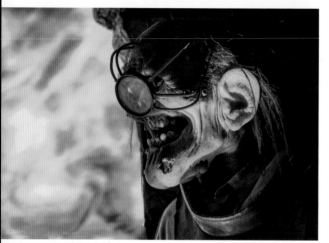

During a recent visit to Clifton Hill, I experienced the House of Frankenstein (above), an attraction that has enticed me since childhood. It's dark in there (this should come as no surprise), and there are red buttons to push to activate fear-inducing features. There are a couple of actors that you'll encounter during your visit who *will* scare you but won't touch you. You'll also delight at the kitschy atmosphere and freakish, macabre props. The fright factor is moderate. I followed behind a family with two tween boys who truly seemed to enjoy the experience and managed to keep their outcries to a dull roar.

As an added bonus, if you purchase a ticket to the House of Frankenstein, you can opt to add on a ticket for Crystal Caves for a few dollars more. Crystal Caves is a mirrored maze. Upon presenting your ticket, the clerk at the desk will provide you with a pair of rubber gloves to don so that you do not leave fingerprints on the mirrored walls and mar the convincing illusion of numerous, endlessly long mirrored corridors—most of which are dead ends. You'll see your own image reflected again and again all around you. It's a disorienting experience that will lead you to rely very much on your sense of touch to navigate to the exit.

Ripley's Believe it or Not! Odditorium (4960 Clifton Hill) is a fascinating place to visit. Once inside, you'll wander through 15 galleries filled with oddities secured from all over the globe—including authentic

shrunken heads and other chin-scratching artifacts and exhibits. The Odditorium is definitely a hit with kids who aren't too squeamish, and adults will get a kick out of it, too. There's no experience quite like it.

A Mario Karts–inspired go-kart attraction is in the works as of this writing.

Once you've worked up an appetite, you can wander over to Mama Mia's, located at 5719 Victoria Avenue, just off of Clifton Hill. The Italian Eatery has been serving tourists and locals since 1958, and it's always busy.

Another fine option for those with a penchant for enjoying ethnic cuisine is The Guru, where you can enjoy fine Indian food in a relaxed, slightly upscale (think white tablecloths and water glasses) restaurant. The traditional options for spicy, savory dishes and fluffy, straight-from-the-oven naan (a leavened, oven-baked Indian flat bread) are palate pleasing.

A few doors down from Mama Mia's, you'll find a casual and comfortable restaurant called The Works. At this gourmet burger joint, you can choose from a variety of patties—beef, chicken, turkey, veggie, mushroom cap, cheese-stuffed beef, and even lean elk. You can then select a bread. From there, choosing a sandwich becomes a bit of a struggle. Everything on the menu has a quirky and delightful name, and there

Paid Parking

For easy access to the Falls and Hornblower Launch site, try the lot on Victoria Avenue, just south of the top of Clifton Hill or the lot located at Fallsview Boulevard and Robinson Street, near the IMAX Theatre. For parking that is nearby the Niagara Parks, Table Rock, and the brink of the Horseshoe Falls, head to the Rapidsview Parking Lot at 7369 Niagara Parkway. This seasonal lot allows for easy access to the WEGO main transfer hub.

are a surprising number of toppings on said burgers. Amongst them are the Son of a Beech burger, with fresh avocado, "Beech-house" sauce, sun-dried tomatoes, and feta cheese. The Barking at My Cow burger is topped with smoked brisket, Barking Squirrel Beer BBQ sauce, caramelized onions, jack cheese, and bacon. Fun, right?

The eatery is vegetarian-friendly and has a wide array of options suitable for diners who have a gluten intolerance. The micro brews on the menu are superb, too; there's even a gluten-free beer offering.

If you have a hankering for something sweet, check out Beavertails Pastry (if you're thinking, *that's an odd name*, consider the fact that the industrious mammal is the national symbol of Canada). President Obama is said to have stopped by to try one of the tasty, hand-stretched whole-wheat treats, shaped to resemble the tail of a beaver, and served hot, when he visited Niagara Falls in 2009. You can customize your treat by choosing your toppings—there's a cinnamon-sugar option, a peanut butter/banana offering, and a host of other goodies, from M&Ms to chocolate hazelnut.

The café also offers yogurts and an array of beverages. The site, located at 4967 Clifton Hill, is an open-air pastry stand—the kind of thing you might find at a carnival. As such, their operating hours vary and are dependent on the weather and season. Go to www.beavertailsinc.com to check their hours. Note that they have limited operation during cold-weather months—from November through April, they are open only on weekends.

■ ELEMENTS ON THE FALLS

If your adventures have left you a little fatigued and hungry or parched, do yourself a favor and head over to Elements on the Falls (6650 Niagara Parkway), located just steps from the Horseshoe Falls, in Table Rock Center. Large windows look onto the Falls, and the view is breathtaking, so be sure to make a reservation for a table with a view, if possible. The eatery can be described as casual/elegant. The menu features steaks and seafoods, with entrées priced at about $30.00 Canadian. Try one of the ice wines from the Niagara region or,

if you're more a fan of craft brews, sample a made-in-Ontario micro brew.

■ BUTTERFLY CONSERVATORY (left)

The Butterfly Conservatory, located on the grounds of the Niagara Parks Botanical Gardens (2565 Niagara Parkway), is a short drive from the Falls. Conservatory visitors will find themselves walking in a tropical paradise full of lush vegetation, relaxing waterfalls, and over 2,000 butterflies. Before heading in to admire the more than 45 butterfly species housed in the attraction, you'll be presented with a short educational video.

The Butterfly Conservatory is a delightful experience for people of all ages and, as it is wholly indoors and in a rain forest setting, it's the perfect activity to enjoy on cold, rainy, or dreary days. Note that two of three Adventure Passes available to visitors (see page 73) include admission to the Butterfly Conservatory. Ticket prices for those without an Adventure Pass are $14.55 (ages 13 and up) and $9.45 (kids 12 and under).

■ BIRD KINGDOM (following page)

Bird Kingdom (5651 River Road) is simply magical. The 50,000-square-foot structure is the world's largest indoor free-flying aviary, and it is home to more than

400 birds and 80 species. In addition to checking out the birds in the Main Aviary, visitors can feed lorikeets and admire more than 40 species (many of which are endangered) in the Small Bird Aviary. Other interesting things to do include viewing night creatures like bats and owls and an array of flightless nocturnal species. You'll want to check out the Javanese Tea Room from the 1800s, built entirely of hand-carved solid teak and constructed without nails.

Visitors to Bird Kingdom report spending roughly 1 to 2 hours at the aviary. The site is open seven days a week, from 9:30am to 5:00pm. Parking in the Bird Kingdom lot is $3.00 per hour. Tickets to the aviary are $17.95 plus tax for adults (ages 16 and up) and $13.95 for kids (ages 4 to 15; children ages 3 and under are admitted free). You can save a couple of dollars on admission prices by purchasing your tickets online. To do so, go to https://tickets.bird kingdom.ca.

■ MARINELAND

Spending the day at Marineland (7657 Portage Road) will prove to be a unique experience for the whole family. The park offers amusement rides suited to all age groups (including the world's largest steel roller coaster, Dragon Mountain), marine animals (whales, dolphins, walruses, and seals—all of whom will perform for you), and land-based zoo animals (bears, elk, and deer, to name a few). A day pass for kids ages 5 through 12 costs $40.95. Tickets for those ages 13 through 59 will set you back $47.95. Tickets to touch and feed beluga whales are available, too—for an added cost.

There's a parking lot on the premises, of course, but it's helpful to know that you can take the WEGO right to Marineland and save yourself the hassle of parking.

■ A LITTLE FARTHER OUT

Lundy's Lane is named for the Battle of Lundy's Lane, part of the War of 1812, which took place in what is now known as Niagara Falls, Ontario. It was one of the bloodiest battles of the war, and among the deadliest of all of the battles fought in Canada.

There's lots to do to keep you busy when you visit historic Lundy's Lane. The kids will love Waves, an indoor water park located in a hotel called The Americana, located at 8444 Lundy's Lane. There's plenty of shopping on Lundy's Lane, too—from plazas to the popular mall, Canada One Brand Name Outlets. You can also spend some time partaking in mini golf or bowling, or check out Niagara Falls Craft Distillers (6863 Lundy's Lane; part of the Syndicate Restaurant & Brewery Complex), which offers Lucky Coin Motel Hand-Crafted Vodka, Lundy's Lane 1814 Small Batch Gin, and Barrelling Annie Whiskey, all available in 750ml bottles in the distillery's retail store.

The WEGO shuttle provides convenient transportation, to and from Lundy's Lane, to the Falls and major Niagara attractions.

Dufferin Islands, located roughly 3 kilometers /.5 miles from the Falls, is an oasis of man-made islands. It's a great spot to picnic, barbecue, hike, or enjoy birdwatching. During winter, the site plays host to the Festival of Lights.

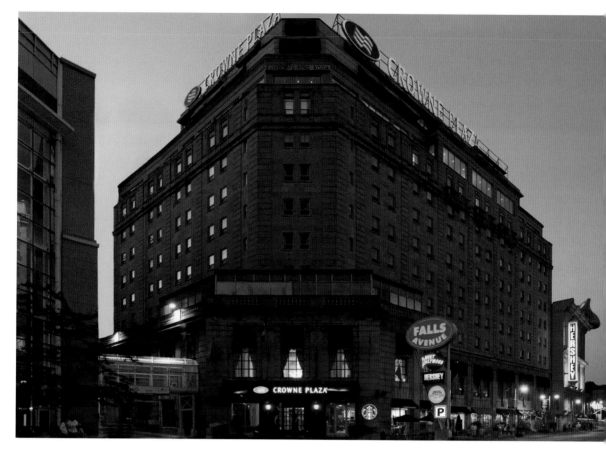
Photo courtesy of Crowne Plaza Niagara Falls—Fallsview Hotel.

If you're looking for a very special dining experience, consider making a reservation at The Buttery Theatre Restaurant (4437 Queen Street), where you can enjoy a Henry VIII medieval-style feast and a show.

Another option for thespians is the dinner theater experience known as Oh Canada, Eh? (8585 Lundy's Lane). Since the establishment opened in 1994, more than 750,000 guests from all over the globe have taken in the top-rated show. You can opt to partake in the performance only or sign on for a night of dinner theater. You'll be entertained by singing Mounties (the name for Canadian police who patrol on horse-back), lumberjacks, Anne of Green Gables, and even a hockey player as the troupe pays tribute to over 30 of Canada's professional recording artists. This family-friendly show is amusing and memorable—and you'll learn some interesting things about Canada and Canadians.

■ ACCOMMODATIONS

There are numerous big-name hotels available alongside the Falls. Many of them offer incredible views. Being limited in space in this book, I've opted to mention some of the lesser-known accommodations, which have something special to offer, as these

places may not be as easily discovered by visitors.

As mentioned in chapter 3, the Crowne Plaza Niagara Falls–Fallsview Hotel (5685 Falls Avenue) once welcomed Marilyn Monroe and other stars of the film *Niagara*. (At the time, the hotel was known as The General Brock.) It's possible to reserve room 801—the room the actress stayed in. The 8th floor is decorated with photographs captured during filming.

Today, rooms start at $129.00 Canadian. The 3-acre Fallsview Indoor Waterpark, with 16 slides, a wave pool, and a kiddie area, make the hotel a great destination for people who are traveling with kids. You can also choose from a variety of packages, with varying price points, to easily plan for extras like a wine tour or extended water park pass during your stay.

The Great Wolf Lodge (3950 Victoria Avenue) is a one-of-a-kind hotelier. Its rustic theme sets it apart from the competition: you can book standard rooms or tent, cave, or cabin-themed rooms that make kids feel as if they are on a camping adventure. There's so much to keep active families busy—including a water park, arcade, kiddie spa (there's one for adults, too), kid-friendly bowling alley with smaller lanes, mini-golf course, and even a "stuffing station" where kids can stuff their own plush souvenir animal. Rates vary widely depending upon the room/theme selected. Visit www.greatwolf .com/niagara for details.

The Lion's Head Bed and Breakfast (5239 River Road) is an Edwardian Arts and Crafts style residence with a handsome porch that overlooks the gorge. It's within walking distance of the Falls and all major attractions. The bed and breakfast is beautifully appointed and features leaded glass windows, a chestnut staircase, and pocket doors. There are five guest rooms. Four of the rooms are named for prominent painters (Gauguin, Monet, Van Gogh, and O'Keefe) and, in decor, give a nod to each painters' style and preferred palette. The fifth room, named French Quarters, is a private suite which features two separate bedrooms. The master bedroom has a king-size bed, large sitting area, fireplace, TV, and a captivating view of the Niagara River. An adjoining bedroom offers a double-size bed. The suite also features a lounge complete with a small fridge, sink, and table. The en suite bathroom features an original claw-foot tub and hand-held shower head. Go to http://lionsheadbb.com to determine the reservable dates and prices.

The Fallsview Tower Hotel (6732 Fallsview Boulevard), adjacent to Queen Victoria Park, is another interesting choice. The four-star hotel offers modern decor and wall-to-wall windows that provide views of the Falls or the city. On the 26th floor of the tower, you'll find an IHOP (International House of Pancakes), a restaurant that offers breakfast favorites, plus burgers, soups, salads, and sides. There is a wedding chapel in the tower, too. With a view of the Falls, it's a great place to start your morning and plan the day's itinerary.

Helpful Resources

Note: This section is comprised of some of the best-reviewed and most unique businesses. It is not a comprehensive list of the region's offerings. Check www.yelp.com or www.tripadvisor.com for additional options in the following categories.

ACCOMMODATIONS

- **Crowne Plaza Niagara Falls–Fallsview Hotel**, 5685 Falls Ave., Niagara Falls, ON, L2E 6W7, www.niagarafallscrowneplazahotel.com
- **Great Wolf Lodge**, 3950 Victoria Ave., Niagara Falls, ON, L2E 7M8 www.greatwolf.com/niagara
- **Lion's Head Bed and Breakfast**, 5239 River Rd., Niagara Falls, ON, L2E 3G9 www.lionsheadbb.com
- **Fallsview Tower Hotel**, 6732 Fallsview Blvd., Niagara Falls, ON, L2G 3W6 www.niagaratower.com

FAMILY FUN

- **Bird Kingdom**, 5651 River Rd., Niagara Falls, ON, L2E 7M7, www.birdkingdom.ca
- **Butterfly Conservatory**, 2565 Niagara Pkwy., Niagara Falls, ON, L0S 1J0 www.niagaraparks.com/visit/attractions/butterfly-conservatory
- **Dinosaur Adventure Golf**, 4960 Clifton Hill, Niagara Falls, ON, L2G 3N4 www.cliftonhill.com/attractions/dinosaur-adventure-golf
- **Dufferin Islands Park**, 7230 Niagara Pkwy., Allanburg, ON, L0S 1A0 www.cliftonhill.com/attractions/niagara-parks/dufferin-islands
- **Falls Incline Railway**, 6650 Niagara Pkwy., Niagara Falls, ON, L2G 6T2 www.niagaraparks.com/hours/falls-incline-railway.html
- **Fallsview Indoor Waterpark**, 5685 Falls Ave., Niagara Falls, ON, L2E 6W7 www.niagarafallshotels.com/niagara-falls-attraction/fallsview-indoor-waterpark
- **Great Wolf Lodge**, 3950 Victoria Ave., Niagara Falls, ON, L2E 7M8 www.greatwolf.com/Niagara
- **Guinness World Records Museum**, 4943 Clifton Hill, Niagara Falls, ON, L2G 3N5
- **Hershey Chocolate World**, 5701 Falls Ave., Niagara Falls, ON, L2E 6W7 www.hersheys.com
- **Hornblower Niagara Cruises**, 5920 Niagara Pkwy., Niagara Falls, ON, L2E 6X8 www.niagaraparks.com/niagara-falls-attractions/hornblower-niagara-cruises.html
- **The House of Frankenstein**, 4967 Clifton Hill, Niagara Falls, ON, L2G 3N5 www.niagarafallshotels.com/niagara-falls-attraction/house-of-frankenstein
- **Journey Behind the Falls**, 6650 Niagara Pkwy., Niagara Falls, ON, L2E 3E8 www.niagaraparks.com/niagara-falls-attractions/journey-behind-the-falls.html
- **Louis Tussaud's Waxworks**, 5709 Victoria Ave., Niagara Falls, ON, L2G 3L5 www.cliftonhill.com/attractions/other-attractions/louis-tussauds
- **Marineland Canada**, 7657 Portage Rd., Niagara Falls, ON, L2E 6X8 www.marinelandcanada.com

- **Niagara Parks Botanical Gardens**, 2565 Niagara Pkwy., Niagara Falls, ON, L2E 2S7
 www.niagaraparks.com/niagara-falls-attractions/botanical-gardens.html
- **Niagara Parks Butterfly Conservatory**, 2405 Niagara Pkwy., Niagara Falls, ON, L2A 5M4
 www.niagaraparks.com›Niagara Falls Attractions
- **Niagara's Fury**, 6650 Niagara Pkwy., Niagara Falls, ON, L2G 0L0, www.niagaraparks.com/
 niagara-falls-attractions/niagaras-fury.html
- **Niagara Sky Wheel**, 4950 Clifton Hill, Niagara Falls, ON, L2G 3N4
 www.cliftonhill.com/attractions/niagara-skywheel
- **Nightmares Fear Factory**, 5631 Victoria Ave., Niagara Falls, ON, L2G 3L5
 www.nightmaresfearfactory.com
- **Oakes Garden Theater**, 5851 Niagara Pkwy., Niagara Falls ON, L2G 3K9
 www.niagaraparks.com/niagara-falls-attractions/oakes-garden-theatre.html
- **Ripley's Believe it or Not! Odditorium**, 4960 Clifton Hill, Niagara Falls, ON, L2G 3N4
 www.ripleys.com/niagarafalls
- **Rock Legends Wax Museum**, 5020 Centre St., Niagara Falls, ON, L2G 3N7
 www.rocklegendswaxmuseum.com
- **Skylon Tower**, 5200 Robinson St., Niagara Falls, ON L2G 2A3, www.skylon.com
- **Whirlpool Aero Car**, 3850 Niagara Pkwy., Niagara Falls, ON, L2E 6T2
 www.niagaraparks.com/niagara-falls-attractions/whirlpool-aero-car.html
- **White Water Walk**, 4330 Niagara Pkwy., Niagara Falls, ON, L2E 6T2
 www.niagaraparks.com/niagara-falls-attractions/white-water-walk.html
- **Whirlpool Golf Club**, 3351 Niagara River Pkwy., Niagara Falls, ON, L2E 6T2
 www.niagaraparks.com/visit-niagara-parks/golf
- **Whirlpool Jet Boat Tours**, 3050 Niagara Pkwy., Niagara Falls, ON, L2E 3E8
 www.whirlpooljet.com
- **WildPlay Niagara Zipline and Aerial Adventure Course**, 5847 River Rd., Niagara Falls,
 ON, L2G 6X8, https://wildplay.com/niagara-falls
- **Winter Festival of Lights**, Niagara Pkwy., Niagara Falls, ON, www.wfol.com
- **Wizard's Golf**, 4960 Clifton Hill, Niagara Falls, ON, L2G 3N4
 www.marriottonthefalls.com/attractions/wizards-golf
- **Zoom Leisure (Bike Rentals)**, 3850 Niagara Pkwy., Niagara Falls, ON, www.zoomleisure.com

NEWSPAPERS

Niagara Falls Review, www.niagarafallsreview.ca

NIGHTLIFE

Note: The legal drinking age in Canada is 19.
- **Beer Garden Karaoke Patio**, 4953 Clifton Hill, Niagara Falls, ON, L2G 3N5
 www.falls.com/beergarden
- **Casino Niagara**, 5705 Falls Ave., Niagara Falls, ON, L2E 6T3, www.casinoniagara.com
- **Club 7 Nightclub**, 5400 Robinson St., Niagara Falls, ON, L2G 2A8
 www.clubsevenniagara.com
- **Club Mardi Gras Bar & Patio Niagara**, 4967 Clifton Hill, Niagara Falls, ON, L2G 3N5
 www.clubmardigrasniagara.com

- **Hard Rock Night Club**, 5705 Falls Ave., Niagara Falls, ON, L2H 6T3
 www.hardrock.com/cafes/niagara-falls-canada
- **Niagara Fallsview Casino Resort**, 6380 Fallsview Blvd., Niagara Falls, ON, L2G 7X5
 www.fallsviewcasinoresort.com
- **R5**, 6380 Fallsview Blvd., Niagara Falls, ON, L2G 7X5, www.niagarafallstourism.com/
 play/nightlife/r5

RESTAURANTS

- **Beavertails Pastry**, 4967 Clifton Hill, Niagara Falls, ON, L2G 3N5
 www.beavertailsinc.com
- **The Buttery Theatre Restaurant**, 4437 Queen St., Niagara Falls, ON, L2E 2L2
- **Elements on the Falls,** 6650 Niagara Pkwy., Niagara Falls, ON, L2E 6T2
 www.niagaraparks.com
- **The Guru**, 5705 Victoria Ave, Niagara Falls, ON, L2G 3L5, www.welcometoguru.com
- **Mama Mia's**, 5719 Victoria Ave., Niagara Falls, ON, L2G 3L5, www.mamamias.ca
- **Oh Canada Eh? Dinner Show**, 8585 Lundy's Ln., Niagara Falls, ON, L2H 1H5
 www.ohcanadaeh.com
- **Revolving Dining Room, Skylon Tower**, 5200 Robinson St., Niagara Falls, ON,
 L2G 2A3, www.skylon.com/niagara-falls-dining/revolving-dining-room
- **The Works**, 5713 Victoria Ave., Niagara Falls, ON, L2G 3L5, www.worksburger.com

RELIGIOUS PLACES OF INTEREST

- **Ten Thousand Buddhas (Cham Shan Temple)**, 4303 River Rd., Niagara Falls, ON,
 L2E 3E8, www.niagarafallstourism.com/services/religious/ten-thousand-buddha-
 temple-of-peace

SHOPPING

- **Canada One Brand Name Outlets**, 7500 Lundy's Ln., Niagara Falls, ON, L2H 1G8
 www.canadaoneoutlets.com

TRANSPORTATION

- **WEGO Niagara Falls Visitor Transportation**, 8208 Heartland Forest Rd., Niagara
 Falls, ON, L2H 0L7, http://wegoniagarafalls.com

Off the Beaten Path: Other Points of Interest

"Niagara Falls is the hanging tongue on the face of the earth, drooling over its own beauty."[14]

—Vinita Kinra

7. NIAGARA-ON-THE-LAKE

Niagara-on-the-Lake is a historic town located at the south shore of Lake Ontario at the mouth of the Niagara River. It was once home to the Neutral Indian village of Onghiara, and it was settled during the American Revolution by Loyalists making their way to Upper Canada. The town was burned to the ground by the Americans during the War of 1812. When it was later rebuilt, Niagara-on-the-Lake began to thrive as a commercial center, with a prospering shipping and ship-building industry.

Niagara-on-the-Lake's charms are many; there's something for every visitor to enjoy.

◾ THE SHAW FESTIVAL

The Shaw Festival is a not-for-profit Canadian theater festival and the second-largest repertory theater company in North America.

When it was founded in 1962, its goal was to stimulate interest in George Bernard Shaw and his period, and to promote the development of theater arts in Canada. Plays are held at four theaters, all of which are within walking distance of one another. The largest of the theaters seats over 850 patrons, while the smaller venues can accommodate roughly 200 attendees.

Enthusiasts can sign up for a 60-minute backstage tour or take classes to build their acting skills. Visit www.shawfest.com for information about performances and tickets.

◾ FORT GEORGE (below and following page)

Fort George National Historic Site (51 Queen's Parade) is located on the Niagara River. The fort was built between 1796 and 1802 and served as the headquarters for the Centre Division of the British Army during

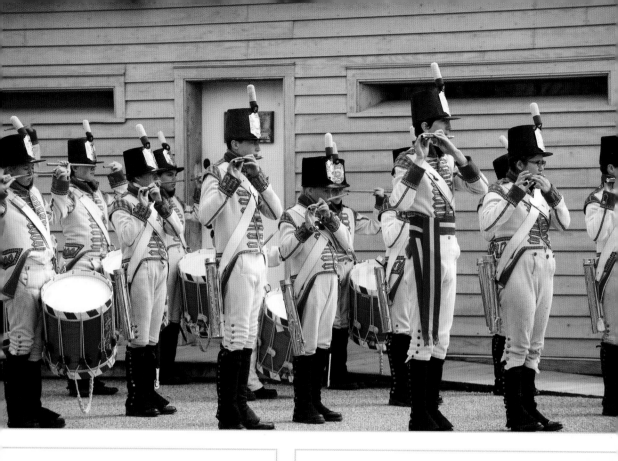

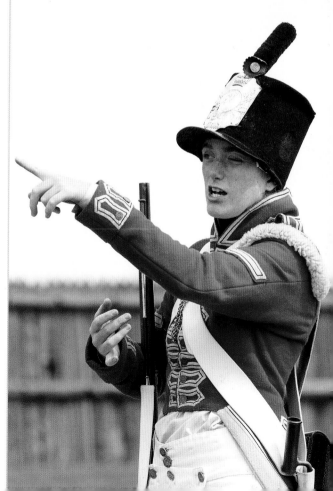

the War of 1812. It also played a key role in the defense of Upper Canada. Fort George saw action during the Battle of Queenston Heights. It was destroyed and captured by the Americans during the Battle of Fort George, then, seven months later, was reclaimed by the British.

When you visit the fort, you can wander through the blockhouses, officers' quarters, artificer's shop, and guard house. Be sure to check out the powder magazine, too; it is the only building that survived the Battle of Fort George, and it is Ontario's oldest military structure. In the summer, you can see performances by the Fife and Drum Corps, watch soldiers' training maneuvers, try food prepared over an open fire in the officers' kitchen, and enjoy musket and artillery demonstrations. If you're brave of heart, you can sign up for a historic ghost tour, too.

The hours of operation vary depending on the season. Check the fort's website (www.friendsoffortgeorge.ca) for the schedule and ticket prices.

■ BUTLER'S BARRACKS NATIONAL HISTORIC SITE

Butler's Barracks National Historic Site is bounded by John Street and King Street. After the War of 1812, work began on a new range of barracks and storehouses on the southwestern edge of the military lands. Butler's Barrack was named for John Butler and his Butler's Rangers—Loyalist soldiers who founded the town of Niagara toward the end of the American Revolution.

While there were 20 buildings on site, only four original British colonial buildings and one Canadian-built structure still stand to memorialize over 150 years of military action. When you visit the site, you'll step back in time and learn the story of Canada's journey from colony to nation.

■ SHOPPING

The shops and boutiques of Niagara-on-the-Lake are quaint and inviting. Wander into one of the stores described below to pick up a gift—or perhaps a little pick-me-up for yourself.

Greaves Jams & Marmalades (55 Queen Street) has a long history and devoted clientele. Browse their gourmet goods and preserves and enjoy a nostalgic shopping experience.

The Name Tree (217 King Street) provides shields, plaques, embroideries, and more with your family's coat of arms. It's an interesting place to stop and learn about your lineage and family history.

Ten Thousand Villages (45 Queen Street) may be my favorite Niagara-on-the-Lake shop. When you walk through the doors, you'll be dazzled by the fair-trade merchandise from all over the globe—including jewelry, toys, musical instruments, home decor, and more.

Wayne Gretzky Estates offers wine and whiskey from hockey great Wayne Gretzky. You will discover The Great One's memorabilia while sampling some of the shop's palette-pleasing options. You can also sign up for a tour or seminar to learn more about the wine-production and distilling process.

A Bite to Eat and Something Sweet

There are a number of incredible places to eat in Niagara-on-the-Lake. However, it's important to save room for dessert—dessert *wine,* that is. Niagara's winters are long and cold. One of the benefits to this climate is the ability for local farmers to harvest grapes used to make ice wine. Ice wine, a type of dessert wine, is produced from grapes that freeze while on the vine. The sugars and other dissolved solids do not freeze, but the water does; this allows for a more concentrated grape must to be pressed from the frozen fruit, resulting in a smaller amount of wine that is wonderfully sweet and concentrated.

■ RESTAURANTS

The Cannery Restaurant, located in Pillar and Post (48 John Street), features steak, seafood, and pasta dishes in a cozy, Tuscan-themed dining room. The exposed brick and beams give the space charm and serve as an homage to the location's former usage as a cannery, which operated from the 1800s until 1957.

The Backhouse (242 Mary Street) is renowned for its cold-climate comfort food, made of locally sourced produce, meats, and cheeses. The executive chef worked in kitchens in Napa Valley, Los Angeles, and San Diego before taking over the reins at the Backhouse. The kitchen creates dishes for everyone—from black walnut smoked trout to chicken liver mousse. Also on the menu is rustic wood-fired sourdough. The chefs can accommodate the needs of those with dietary restrictions and food allergies.

A visit to Treadwell (114 Queen Street) may upend any preconceived notions you have about what it means to enjoy a great meal.

The menu features inventive dishes made with locally sourced seasonal produce from artisan producers. On the lunch menu as of this writing, you'll find owner/chef Stephen Treadwell's Pan Seared East Coast Sea Scallops with Guanciale Charred Sweet Corn & Sunflower Seed Risotto and Chili Vinaigrette. Current dinner options include Indian Spice Dusted West Coast Halibut with Local Sweet Corn, Curry Roasted Peanuts, and Cilantro & Lime Yogurt. Yes. It's an inspired menu.

The restaurant carries its farm-to-table philosophy to its wine list, too. Though the restaurant's wine list includes varieties from around the globe, they strive to offer an ever-evolving selection of wines from local artisan producers who practice clean, ecologically responsible farming.

■ ACCOMMODATIONS

If you prefer more relaxing, quieter accommodations than you will find in Niagara Falls, Canada, consider making a reservation at one of the beautiful inns of Niagara-on-the-Lake. The drive from the Falls to Niagara-on-the-Lake takes only minutes, and it's perfectly picturesque.

La Toscana Di Carlotta at Burns House (255 King Street), one of the oldest homes in town, is a Tuscan-style inn with a rich history. Local historians say it once served as a home for a British army officer, was destroyed in the War of 1812, and was rebuilt in 1818. At the inn, you'll enjoy Italian breakfasts and repose on fine Italian linens.

The Olde Angel Inn was established in 1789, destroyed by fire in 1812, and rebuilt in 1815. This British-themed inn is Niagara-on-the-Lake's oldest operating inn and features five guest rooms, an English-style pub, and three gas fireplaces, one in each of the three dining areas.

Beware! Legend has it that the inn is a favorite "haunt" of the spirit of Captain Colin Swayze.

The vintage hotels in Niagara-on-the-Lake are absolutely breathtaking and are a step above the day-to-day accommodations that the chain hotels offer. There are a number of hotels to choose from. The Prince of Wales (6 Picton Street), a romantic and luxurious Victorian-style hotel, is located steps away from unique shops and boutiques and the Shaw Festival Theatre. The Pillar and Post (48 John Street West) boasts 122 guest rooms, which are designed with a blend of contemporary and country furnishings and luxurious amenities. The inn, originally built as a canning factory, features natural brick, exposed beams, terra cotta tile, and is home of the award-winning Cannery Restaurant.

■ WHIRLPOOL JET BOAT TOURS

If you have a couple of hours to spare (it's roughly a 1-hour tour, but there's some preparation to do before you head out on the water) and are looking for a memorable experience, consider booking a Whirlpool Jet Boat Tour. Your guide will discuss the history and geology of the Niagara River as you ride through the class-5 rapids. You'll be given a poncho and don water shoes and a life jacket, too. The Whirlpool Jet Boats also have a tour that launches from Lewiston, New York. You can find contact information for that tour in the chapter 8 "Helpful Resources" section.

■ CARRIAGE RIDES (left)

Sentineal Carriages (www.sentinealcarriages.ca) offers horse-drawn carriage rides. A variety of carriages are available, depending on the time of year. Knowledgeable guides will treat you to stories and facts about Niagara-on-the-Lake and the Niagara region as you catch a glimpse of beautiful gardens and historic points of interest.

Helpful Resources

Note: This section is comprised of some of the best-reviewed and most unique businesses. It is not a comprehensive list of the region's offerings. Check www.yelp.com or www.tripadvisor. com for additional options in the following categories.

ACCOMMODATIONS
- **The Olde Angel Inn**, 224 Regent St., Niagara-on-the-Lake, ON, L0S 1J0, www.angel-inn.com
- **Pillar and Post**, 48 John St. West, Niagara-on-the-Lake, ON, L0S 1J0
 www.vintage-hotels.com/pillarandpost
- **Prince of Wales**, 6 Picton St, Niagara-on-the-Lake, ON, L0S 1J0, www.vintage-hotels.com/ princeofwales
- **La Toscana Di Carlotta at Burns House**, 255 King St., Niagara-on-the-Lake, ON, L0S 1J0
 www.latoscanadicarlotta.com

FAMILY FUN
- **Butler's Barracks National Historic Site**, John St. and King St., Niagara-on-the-Lake, ON, L0S 1J0, www.friendsoffortgeorge.ca
- **Fort George National Historic Site**, 51 Queen's Parade, Niagara-on-the-Lake, ON, L0S 1J0, www.friendsoffortgeorge.ca
- **Sentineal Carriages**, http://sentinealcarriages.ca; visit the website to make reservations
- **Shaw Festival**, 4 theater locations, www.shawfest.com
- **Whirlpool Jet Boat Tours**, 61 Melville St., Niagara-on-the-Lake, ON, L0S 1J0
 www.whirlpooljet.com/jet-boating/niagara-on-the-lake
- **Zoom Leisure** (Bike Rentals), 431 Mississagua St., Niagara-on-the-Lake, ON L0S 1J0
 www.zoomleisure.com

RESTAURANTS
- **Backhouse**, 242 Mary St., Niagara-on-the-Lake, ON, L0S 1J0, www.backhouse.xyz
- **The Cannery**, 48 John St. West, Niagara-on-the-Lake, ON, L0S 1J0, www.fine-dining.ca/ cannery-restaurant.htm
- **Treadwell**, 114 Queen St., Niagara-on-the-Lake, ON, L0S 1J0, www.treadwellcuisine.com

SHOPPING
- **Greaves Jams & Marmelades**, 55 Queen St., Niagara-on-the-Lake, ON, L0S 1J0
 www.greavesjams.com
- **The Name Tree**, 217 King St., Niagara-on-the-Lake, ON, L0S 1J0, www.thenametree.com
- **Niagara-on-the-Lake Jewellers and Precious Metal Studio**, 38 Market St., Niagara-on-the-Lake, ON, L0S 1J0, www.notljewellers.com
- **Ten Thousand Villages**, 45 Queen St., Niagara-on-the-Lake, ON, L0S 1J0
 www.tenthousandvillages.ca
- **Wayne Gretzky Estates**, 1219 Niagara Stone Rd., Niagara-on-the-Lake, ON, L0S 1J0
 www.gretzkyestateswines.com

8. LEWISTON

Lewiston, New York, is a historic village located 7 miles north of Niagara Falls. It is home to a number of interesting cultural institutions and places of interest.

■ THE FREEDOM CROSSING MONUMENT (below)
The book *Freedom Crossing* by author Margaret Goff Clark is a mandatory read for many students. The book details the lives of persons who escaped slavery (and those who helped them) via the Underground Railroad. Historically, Lewiston, New York, was a gateway to Canada, where slaves could live as free persons.

Many of the places of interest mentioned in the book still stand in Lewiston. There is also a bronze statue on the bank of the Niagara River named *Freedom Crossing*. (Note: The photo below shows only a portion of the monument.) Webcams have been installed at the monument site. You can view them at http://historiclewiston.org/freedomcrossingwebcam.html.

The Niagara Power Project Visitor's Center, located 5 miles from Niagara Falls, is a great destination for science-minded travelers to the Niagara region. Located at 5777 Lewiston Road, the attraction boasts hands-on exhibits and a virtual reality ride that educate visitors about power generation. Special community events, from movie days to wildlife exhibits, are scheduled throughout the year. Visitors are admitted to the center free of charge.

■ ARTPARK
Artpark (450 South 4th Street) is situated on the beautiful New York State Park, high atop the Niagara River Gorge. The venue hosts an array of concerts featuring national recording artists, plus productions of Broadway shows and performances by the Buffalo Philharmonic Orchestra.

Artpark also offers hiking trails and nature sites, areas to picnic, and spots to fish.

■ BASILICA OF THE NATIONAL SHRINE OF OUR LADY OF FATIMA (right)

Our Lady of Fatima Shrine (1023 Swann Road) was established in 1954. Since that time, the shrine has welcomed thousands of visitors who have made the journey to partake in prayer and spiritual renewal—or simply to appreciate the beauty and splendor of the site.

The shrine is situated on meticulously manicured grounds that feature paths which wind past more than 100 life-sized statues of saints from all walks of life and around the world. There is also a beautiful pond called the Rosary Pool on the property. The most striking feature, however, is the dome of the basilica, which is covered with glass and Plexiglas and provides a depiction of the Northern Hemisphere on the surface.

Visitors to the basilica can climb two flights of stairs to arrive at the top of the dome to admire a huge, 10-ton, 13-foot granite statue of Our Lady of Fatima. From this vantage point, the expanse of the site can be seen.

■ THE CASTELLANI ART MUSEUM

The Castellani Art Museum, located in the center of the picturesque Niagara University campus (5795 Lewiston Road), is Niagara County's only collecting museum. The Castellani's permanent collection includes over 5500 pieces—the majority of which can be classified as modern or contemporary art works. The museum hosts numerous exhibitions that honor and explore the artistic traditions and contemporary output of artists from a diversity of ethnic and cultural backgrounds.

■ TUSCARORA HEROES MONUMENT (below)

The Tuscarora Heroes Monument is located at the corner of Center Street and Portage Road. The dramatic monument—a piece which consists of three figures—was erected as a nod to the Tuscarora Nation for saving the lives of dozens of local residents during the War of 1812 British attack on December 19, 1813.

■ THE MARBLE ORCHARD HISTORIC WALKING TOURS AND GHOST TOURS

If you're a history buff or want to commune with the spirits said to haunt Lewiston, check out the Marble Orchard tours. Stories are told by actors who represent local residents from the mid-1800s—many of whom are buried in the Village Cemetery. Call 716.754.0166 for details.

■ APPLE GRANNY RESTAURANT

Apple Granny, located at 433 Center Street, is a quaint and cozy, unpretentious eatery that specializes in American food favorites. From burgers, to fish fries, to pasta dishes, there's something for everyone. Be sure to try the namesake dessert, the Caramel Apple Granny, and indulge in a little gooey goodness.

■ THE SILO

The Silo is a favorite restaurant amongst locals—though visitors may recall that it was featured on *Man v. Food* in 2010. Host Adam Richman loved the menu—particularly the regional favorite, Beef on Weck, and the restaurant's signature sandwich, the "Haystack," which, according to the Silo's website, Richman called "The holy trinity of dude food!"

The structure dates back to the 1930s, when the silo and a terminal were built to accommodate thousands of passengers transferring from the Great Gorge Railway and boarding steamers in Lewiston to travel to Toronto. The silo housed the coal that fueled the steamers and played a critical role in keeping the waterfront alive. In 1938, an ice jam damaged most of the terminal, and it was razed. In 1997, Richard Hastings, a local businessman, sought to convert the silo into a refreshment stand. Soon after, he turned the business over to his son Alan, whom he believed had the passion and energy to ensure the venture would thrive.

Interesting note: The Silo's tables, seats, and countertops are made from recycled church pews. Food and drink are served on/in plant-based products.

■ FESTIVALS

Lewiston is home to a several fabulous festivals during the summer.

The Lewiston Art and Chalk Festival is held annually in August. The large and popular event is held on Center Street, a Lewiston thoroughfare, and it features over 150 artists and scores of paintings, sculpture, ceramics, jewelry, fiber, glass, wood, mixed media, and photography. Entertainment is provided by street musicians and performers. A chalk-drawing competition is an important component of the festival, too. For more information, go to www.artcouncil.org/art-festival.

The Lewiston Jazz Festival is the largest outdoor jazz fest in Western New York. Held in late August, the event boasts five stages, food, shopping, and fun. This festival, too, is held on Center Street. For details, go to www.lewistonjazz.com.

In September, the end of summer and back-to-school season are marked by the start of the Lewiston Peach Festival, held at 100 Portage Road. The event features entertainment, midway rides, an array of vendors, and tasty peach treats—including shortcake and even peach soda. You can find this year's schedule at www.lewiston peachfestival.org.

Helpful Resources

Note: This section is comprised of some of the best-reviewed and most unique businesses. It is not a comprehensive list of the region's offerings. Check www.yelp.com or www.tripadvisor.com for additional options in the following categories.

FAMILY FUN
- **Artpark State Park**, 450 South 4th St., Lewiston, NY 14092, www.artpark.net
- **Castellani Art Museum**, Niagara University, 5795 Lewiston Rd., Lewiston, NY 14109, www.castellaniartmuseum.org
- **Freedom Crossing Monument**, http://historiclewiston.org/freedomcrossingwebcam.html
- **Lewiston Art and Chalk Festival**, Center St., Lewiston, NY 14092, www.artcouncil.org/art-festival
- **Lewiston Jazz Festival**, Center St., Lewiston, www.lewistonjazz.com
- **Lewiston Peach Festival**, 100 Portage Rd., Lewiston, NY 14092 www.lewistonpeachfestival.com
- **Marble Orchard Ghost Walks and Historic Walking Tours**, www.artcouncil.org/living-history
- **Niagara Power Visitor's Center**, 5777 Lewiston Rd., Lewiston, NY 14092, www.nypa.gov
- **Tuscarora Heroes Monument**, Center St. and Portage Rd., Lewiston, NY 14092
- **Whirlpool Jet Boat Tours**, 115 South Water St., Lewiston, NY 14092, www.whirlpooljet.com

RESTAURANTS
- **Apple Granny Restaurant**, 433 Center St., Lewiston, NY 14092, www.applegranny.com
- **The Silo**, 115 N Water St., Lewiston, NY 14092, www.lewistonsilo.com

9. LOCKPORT

Lockport, New York, a historic city incorporated in 1865, gets its name from a set of Erie Canal locks located in the city.

◼ THE ERIE CANAL (below and following page)

The canal, often referred to as "Clinton's Big Ditch" by opponents to the project, was proposed in 1808 and completed in 1825. It was dug solely by hand, mainly due to the efforts of Irish and Scottish immigrant laborers. Upon completion, it was the engineering marvel of its day. The canal "included 18 aqueducts to carry the canal over ravines and rivers, and 83 locks, with a rise of 568 feet from the Hudson River to Lake Erie. It was 4 feet deep and 40 feet wide, and floated boats carrying 30 tons of freight. A 10-foot wide towpath was built along the bank of the canal for the horses and/or mules which pulled the boats and their driver, often a young boy . . ."[15]

In 1836, after an increase in canal traffic, the canal was enlarged to enable boats carrying up to 240 tons of cargo to pass, and a number of locks were removed. In 1903, New York State approved another expansion. The Barge Canal—consisting of the Erie Canal, Champlain Canal, Oswego Canal, and the Cayuga and Seneca Canals—was constructed and completed in 1918.

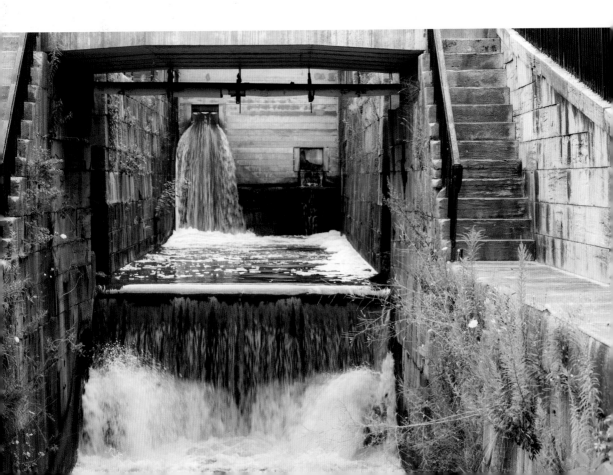

The Erie Barge Canal is now up to 14 feet deep, 200 miles wide, and 338 miles long.[16] Locks were built to allow barges carrying up to 3000 tons of cargo to transverse the canal. Today, the Erie Canal is trafficked mainly by recreational vessels. Five of the original locks are still in place (two of which have been restored, with the remaining three slated for restoration). You can also take a narrated sight-seeing cruise to get a better sense of the importance of Lockport in U.S. history.

As you walk along the canal, you will also find signs that describe the canal's historical significance, such as one that asks you to notice the grooves worn into the wrought-iron railings after year upon year of locktenders in Lockport "tying off" boats to control the boats' positions. You'll also discover the Erie Canal Museum, a couple of old boats, and a well-maintained landscape.

To get to the Lockport Locks, navigate to 210 Market Street.

■ HIKE, BIKE, AND FISH

Trails that wind their way alongside the canal and lead to adjacent parks offer stunning reflections of some of Lockport's beautiful old bridges, architecture, and even water fowl (see the photos on page 109).

tour that begins with an introduction to Erie Canal Locks 67–71, constructed in 1838. While on the tour, you will also see ruins from the Industrial Revolution and walk through a water tunnel that was blasted out of solid rock. Finally, you'll take an underground boat ride (yes, it's a bit unsettling, but it's worth it) through a 1600-foot/487.68 meter eerily quiet tunnel and view stalactites, flow stone, and various rock formations. The air smells and tastes of mineral deposits, and the memory will stay with you. An experience like no other is the opportunity to gaze at the artifacts left behind by the men who built the tunnel during the early days of the Erie Canal.

Tickets are sold at 5 Gooding Street. The cost for adults is $15.00, and kids' tickets are $10.00 (ages 6 through 12) and $5.00 (age 5 and under).

The paths are well-maintained and easy to navigate by foot or on bike. There are also places to picnic and fish.

A zip line that crosses over the Erie Canal is under construction as of this writing.

■ THE LOCKPORT CAVE AND UNDERGROUND BOAT RIDE

One of the most unique and fascinating local adventures I have enjoyed in the past few years was a tour of the Lockport Cave. Participants head out on a 70-minute guided

■ ART, ANTIQUES, BOUTIQUES, AND MORE

Art lovers will want to check out the Kenan Center (433 Locust Street). Also, Louis Comfort Tiffany's stained-glass windows can be admired on the Tiffany Windows Tour (21 Church Street). Antique stores and boutiques that offer an eclectic array of goods dot this quaint city as well.

The historic Palace Theatre (2 East Avenue) is a dream destination for movie-goers. Built in 1925, the theater offers blockbuster movies, and the building features "original murals, a proscenium arch around the stage, and intricate grillwork covering the pipes of the original Wurlitzer organ."[17] This gorgeous theater is a testament to Lockport's history as an important cultural and economic center.

A BITE TO EAT

There is no shortage of places to eat in Lockport—but some of the best-loved spots may come as a surprise. If you're spending the day by the canal or take a Lockport Cave tour, be sure to check out Lake Effect Artisan Ice Cream. Consider the fact that they offer whiskey/brown-sugar ice cream, a black sesame ice cream, and a "chicken and waffles" sundae, complete with chicken-infused caramel. Don't worry; there are plenty of options to satisfy those who prefer "safer" flavors, too.

The New York Beer Project (6933 Transit Road) is a relatively new Lockport pub and eatery. It is housed in a giant brick building and has an outdoor patio. The interior has an industrial vibe, and the beer options are astounding. The eatery specializes in American cuisine—with a daring side.

Shamus Restaurant (98 West Avenue) is a top pick for seafood, steaks, chicken, and other American staples.

Aguacates Authentic Mexican Restaurant (5674 S. Transit Road) is popular with locals and tourists who prefer a meal with ethnic flair.

If you're traveling with kids or are in the mood for something quick and easy, don't miss Reid's Drive In (150 Lake Avenue). This slice of Americana offers burgers, dogs, shakes, fries, and rings—you know, the five food groups.

THE WINE TRAIL

More than half a dozen wineries will welcome you with open arms when you visit Lockport. For small change, you can taste a number of home-grown, world-class wines, and often tempt your palate with some wine pairings. Play it safe if you plan to imbibe. Go to https://niagarawinetrail.org to check out your transportation options and the various available tours.

MURPHY ORCHARDS

On the Murphy Orchards property, you will find a historic barn that was a stop on the Underground Railroad. You can catch a glimpse of the area where slaves briefly lived as they made their escape to Canada. You can also view abandoned relics and watch a short film on the Underground Railroad. There's a tea house on the property with delicious menu items, and you can purchase jams, jellies, and relishes made from the farm's produce in an adjacent shop. Seasonally, you can also pick apples and other fruit.

Note: Murphy Orchards is not in Lewiston, but it is close by. It is located at 2402 McClew Road, Burt, New York, 14028. I chose to add it to this section as Burt is a hamlet in the Town of Newfane, where visitors will find mainly farmland and private residences.

THE FINAL VERDICT

Lockport is located roughly 18 miles east of the city of Niagara Falls. It's a great place to spend the day if you have your own transportation and want to enjoy a historically rich getaway.

Helpful Resources

Note: This section is comprised of some of the best-reviewed and most unique businesses. It is not a comprehensive list of the region's offerings. Check www.yelp.com or www.tripadvisor.com for additional options in the following categories.

ACCOMMODATIONS
- **Niagara Crossing Hotel & Spa**, 100 Center St., Lewiston, NY 14092 www.bartonhillhotel.com

FAMILY FUN
- **Lockport Cave and Underground Boat Ride**, 5 Gooding St., Lockport, NY 14094 www.lockportcave.com
- **Lockport Locks and Erie Canal**, 210 Market St., Lockport, NY 14094 www.lockportlocks.com
- **Murphy Orchards**, 2402 McClew Rd., Burt, NY 14028, www.murphyorchards.com

NEWSPAPER
- *Lockport Union-Sun & Journal*, www.lockportjournal.com

RELIGIOUS PLACES OF INTEREST
- **Tiffany Windows of First Presbyterian Church**, 21 Church St., Lockport, NY 14094 www.1stpreslockport.org

RESTAURANTS
- **Aguacates Authentic Mexican Restaurant**, 5674 S. Transit Rd., Lockport, NY 14094 www.aguacateslockport.com
- **Lake Effect Ice Cream**, 79 Canal St., Lockport, NY 14094, www.lakeeffecticecream.com
- **The New York Beer Project**, 6933 Transit Rd., Lockport, NY 14094 www.nybeerproject.com
- **Reid's Drive In**, 150 Lake Ave., Lockport, NY 14094, www.facebook.com/reids.in
- **Shamus Restaurant**, 98 West Ave., Lockport, NY 14094, www.theshamus.com

WINERIES
- **Honeymoon Trail Winery**, 4120 Ridge Rd., Lockport, NY 14094 http://honeymoontrailwinery.com
- **Flight of Five Winery**, 2 Pine St., Lockport, NY 14094 http://flightoffivewinery.com

10. YOUNGSTOWN

The historic village of Youngstown, New York, is located just 11 miles north of Niagara Falls, New York, in the Town of Porter. It is right across the river from Niagara-on-the-Lake.

The village offers visitors and locals opportunities to enjoy fishing, sailing, kayaking, and water skiing. Of course, the village has more to offer than its natural charms.

■ **OLD FORT NIAGARA** (left and following page)
Old Fort Niagara (4 Scott Avenue) is the oldest continuously occupied military site in North America. The fort is on the National Historic Register, is open year-round, and welcomes over 100,000 visitors every year.

The Fort celebrates its rich history by offering numerous special events at which visitors can engage with re-enactors and learn about the lives of soldiers during their encampment at the Fort during pivotal moments in history. There are also battle re-enactments and vendors selling historically themed merchandise on-site during the special events. It's a fun and entertaining way for families or individuals to spend the day.

Old Fort Niagara's past is glorious; a detailed account of the action that took place there would require much more space than this book allows. However, it is worth mentioning that the existing buildings date back to the early 18th century, and that the fort was home to

empires that struggled for control over North America. The historic artifacts at the fort, including its original War of 1812 Flag, will delight history buffs.

■ FORT NIAGARA STATE PARK

Fort Niagara State Park, located on Route 18F, adjacent to Old Fort Niagara, has a lot to offer visitors to Youngstown. The park provides boat launches, picnic areas, nature trails, playgrounds, and more.

Visitors can also enjoy the public swimming pool, gaming fields, and playground. The park is a great destination for nature lovers (there's a nature discovery center that is open during warm-weather months), and there are numerous trails that are perfect for hiking and biking. Sporting enthusiasts can enjoy hunting and fishing, too. In the winter, the park is a great place to enjoy sledding, cross-country skiing, and even snowshoeing.

■ ONTARIO HOUSE (below)

Ontario House (358 Main Street), also known as The Stone Jug, is one heck of a fun place to have a bite to eat—or a couple of drinks. The building dates back to 1842, when it served as a 19th-century watering hole. The establishment's exterior may well lead you to think that stepping inside will be a costly decision, but you'll be pleasantly surprised to discover how reasonably priced the food and drinks are. It is truly a laid-back establishment. Dining on the front porch will allow you to partake in some people-watching.

Ontario House is open for brunch and dinner, seven days a week. An added bonus? There's an old shuffleboard table (pictured on the left) next to the bar. If you've never played, give it a try; it's a lot of fun.

■ TRAVEL TIP

If you're in the Falls and want to check out destinations in Lewiston and Youngstown, consider taking the free Discover Niagara shuttle. For schedules and destinations, go to www.discoverniagarashuttle.com.

Helpful Resources

Note: This section is comprised of some of the best-reviewed and most unique businesses. It is not a comprehensive list of the region's offerings. Check www.yelp.com or www.tripadvisor .com for additional options in the following categories.

ACCOMMODATIONS
- **Driftwood Acres Summer Home**, 536 Second St., Youngstown, NY 14174 716.745.3004
- **Lakeview Motel & Cottage**, 2000 Lake Road, Youngstown, NY 14174 www.lakeviewmotelandcottage.com
- **Nucci B & B Elite Accommodations**, 525 Main St., Youngstown, NY 14174, www.airbnb .com/rooms/830353

FAMILY FUN
- **Fort Niagara State Park**, Rt. 18F, Youngstown, NY 14174, www.parks.ny.gov
- **Old Fort Niagara**, 4 Scott Ave., Youngstown, NY 14174, www.oldfortniagara.org

RESTAURANTS
- **Bandana's Bar & Grill**, 930 Lake Rd., Youngstown, NY 14174, 716.745.1010
- **Ontario House**, 358 Main St., Youngstown, NY 14174, 716.219.4073
- **The Mug and Musket**, 418 Main St., Youngstown, NY 14174, www.niagarariverregion.com
- **Youngstown Village Diner**, 425 Main St., Youngstown, NY 14174, www.youngstown villagediner.com

RELIGIOUS PLACES OF INTEREST
- **Basilica of the National Shrine of Our Lady of Fatima**, 1023 Swann Rd., Youngstown, NY 14174, www.fatimashrine.com

11. GRAND ISLAND

The Town of Grand Island, New York, is located between Niagara Falls, New York, and Buffalo, New York. The island, one of the largest freshwater islands in the United Stated, is the size of Manhattan. Visitors and locals can enjoy a wide array of amenities—including three marinas, four bike trails, a KOA campsite, two state parks, a farmer's market, snowmobile trails, hunting sites, an amusement park, and more.

■ BEAVER ISLAND STATE PARK (below)

Beautiful Beaver Island State Park is located at the end of South Parkway, one of the town's major roads (enter 2136 West Oakfield Road into your map app or GPS). The park offers a large parking lot, sandy beach, snack shop, marina, golf course, picnic areas/shelters, disc golf course, volleyball/basketball, fishing, baseball fields, orienteering, sledding hill, and cross-country skiing. The park is also home to the historic River Lea House, built in 1849, which was once the summer home of former President Grover Cleveland.

The park is a fun and budget-friendly option ($7.00 per vehicle) for families; it's also a great place to take a romantic walk on the beach or commune with nature.

■ BUCKHORN ISLAND STATE PARK (following page)

Located at the northern edge of Grand Island on East River Road, Buckhorn Island is an ideal destination for physically active

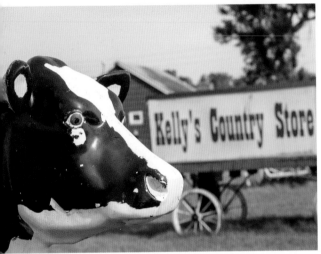

Ticket prices range from $19.99 to $21.99 when purchased online; the cost of admission is slightly higher at the gate. You can save money if you purchase your ticket at the gate after 5:00pm. At that time, the cost per ticket drops to a very affordable $17.99.

■ GRAND ISLAND FUN CENTER

A short distance away from Fantasy Island, you'll find the Grand Island Fun Center (2660 Grand Island Boulevard). This fun-for-the-whole-family establishment offers go-karts, mini golf, a batting cage, an indoor arcade, laser tag, and food. There is no cost to enter. Individual attraction costs vary.

■ KELLY'S COUNTRY STORE (left)

When you visit Kelly's Country Store (3121 Grand Island Boulevard), you'll feel as if you have stepped back in time. There are old farming implements on the grounds, and antiques decorate the interior. There's even a historic school house, built in the 1870s, on site. When you enter the shop and head toward the counter, you'll quickly take note of the large glass canisters filled to the rim with old-fashioned candies (and some contemporary favorites). The store also sells gift merchandise; jams, jellies, salsas, and other culinary supplies; and lots of tempting handmade chocolates. At Christmas and Easter, Kelly's Country Store really shines. Seasonal chocolates take up a vast amount of space, and Santa Claus and the Easter Bunny are available to amuse visiting children over the holidays.

Normal business hours are 10:00am to 6:00pm, seven days a week.

individuals, couples, and children. The park serves as a wildlife refuge and provides fishing, hiking, bicycling, walking, and cross-country skiing opportunities.

■ MARTIN'S FANTASY ISLAND

Martin's Fantasy Island, located at 400 Grand Island Boulevard, is home to over 35 rides, water slides, and a variety of family-friendly shows. It's a moderately priced theme park and easy to navigate. The lines for the rides are never dauntingly long, which means you'll pack more fun and adventure into your visit than you might at a larger park. Be sure to check out the Wild West Shoot-Out while you are there. It's . . . well, a blast!

■ DICK & JENNY'S BAKE AND BREW (below)

There's nothing like Dick & Jenny's (1270 Baseline Road). The eatery's proprietors, Dick and Jenny Benz, met and married in New Orleans and opened an uptown diner there. When Hurricane Katrina struck the city in 2005, the couple lost their home. They decided to sell their restaurant to their employees (it's still open for business and enjoying much success) and relocate to Grand Island, New York, to be closer to their families.

Soon after Dick and Jenny made their move, the pair decided to open a new restaurant. The building they chose (formerly called Del & Herb's) fit the bill. It was built in the late 1800s and once served as a dance hall and neighborhood pub.

Dick & Jenny's offers breakfast and lunch, then closes mid-afternoon to prepare for their dinner guests. The menu options are simply out of this world. From incredible omelettes with sides like fresh fruit and corned beef hash and fresh-baked pastries, to soups, salads, and gourmet sandwiches (including po' boys), to dinnertime offerings from New Orleans and favorites like pastas, seafood, and steak, there is something for everyone. If you have a hearty appetite, you'll want to go all-in and order from the tasting menu.

When you dine at Dick & Jenny's, you'll feel as if you're in a residential dining room. The antique bar and drink menu will delight, the staff is courteous and efficient, and there are dinner plates on the wall decorated by the eatery's early customers. All in all, the restaurant is cozy, comfortable, and impossibly charming. On select evenings,

you can even catch live music—from a New Orleans style ragtime performer who tickles the ivories every Thursday, to acoustic sets, funk, and more. If you plan to be in the Niagara region for Mardi Gras, visiting Dick & Jenny's is a must. It's a heck of a party. Reservations are recommended.

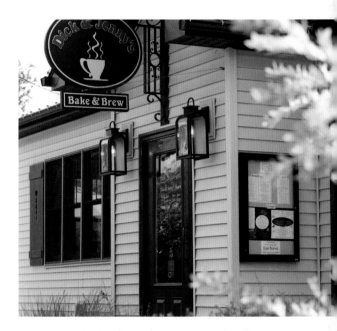

■ THE VILLAGE INN

The quaint and cozy Village Inn (1488 Ferry Road) is tucked away at the end of a quiet, semi-residential street, in Grand Island's historic Ferry Village. The restaurant is a favorite amongst locals, and it is known for its fish fry and award-winning soups—but the balance of the menu and the Inn's daily specials are equally impressive.

When you visit the Inn, be sure to try the fried pickles and indulge in one of the kitchen's fresh-baked desserts. Wednesdays and Fridays (fish-fry days) are exceptionally busy, so be sure to call 716.773.5030 for reservations.

■ MOMMA DE'S MIXING BOWL

Momma De's Mixing Bowl (1879 Whitehaven Road) is Grand Island's only full-service bakery. Choose from savory items like wraps or pizza biscuits or indulge in a fresh-baked cupcake, cookie, or slice of cheesecake—with a fresh-brewed mug of java for good measure. The bake shop is filled with natural light, and there's artwork by Niagara-region artists for sale, too.

Helpful Resources

Note: This section is comprised of some of the best-reviewed and most unique businesses. It is not a comprehensive list of the region's offerings. Check www.yelp.com or www.tripadvisor.com for additional options in the following categories.

ACCOMMODATIONS

- **Niagara Falls/Grand Island KOA**, 2570 Grand Island Blvd., Grand Island, NY 14072
 http://koa.com/campgrounds/niagara-falls-new-york

FAMILY FUN

- **Beaver Island State Park**, 2136 W. Oakfield Rd., Grand Island, NY 14072
 www.parks.ny.gov
- **Buckhorn Island State Park**, 5805 E. River Rd., Grand Island, NY 14072
 www.parks.ny.gov
- **Grand Island Fun Center**, 2660 Grand Island Blvd., Grand Island, NY 14072
 716.775.0180
- **Kelly's Country Store**, 3121 Grand Island Blvd., Grand Island, NY 14072
 www.kellyscountrystore.com
- **Martin's Fantasy Island**, 2400 Grand Island Blvd., Grand Island, NY 14072
 www.fantasyislandny.com

RESTAURANTS

- **Dick & Jenny's Bake & Brew**, 1270 Baseline Rd., Grand Island, NY 14072
 www.dickandjennysny.com
- **Momma De's Mixing Bowl**, 1879 Whitehaven Rd., Grand Island, NY 14072
 www.mommadesmixingbowl.com
- **Village Inn**, 1488 Ferry Rd., Grand Island, NY 14072, www.villageinngrandisland.com

ADDITIONAL READINGS

REFERENCES AND GUIDEBOOKS

- Austin, Thomas. *Niagara Falls Travel Guide.* (Astute Press, 2014)
- Butters, Kerry. *A Visit to Niagara Falls.* (CreateSpace Independent Publishing Platform, 2017)
- Charles River Editors. *Niagara Falls: The History of North America's Most Famous Waterfalls.* (CreateSpace Independent Publishing Platform, 2015)
- Goff Clark, Mary. *Freedom Crossing.* (Scholastic, 1980)
- Gromosiak, Paul and Christopher Stoianoff. *Niagara Falls: 1850–2000.* Images of America series. (Arcadia Publishing, 2012)
- Swift, Jody. *Niagara Falls Travel Guide: Sights, Culture, Food, Shopping & Fun.* (CreateSpace Independent Publishing Platform, 2016)
- Gibbs, Lois Marie. *Love Canal and the Birth of the Environmental Health Movement,* 3rd Edition. (Island Press, 2010)
- Newman, Richard S. *Love Canal: A Toxic History from Colonial Times to the Present.* (Oxford University Press, 2016)

FICTION SET IN THE NIAGARA REGION

- Belfer, Lauren. *City of Light.* (Bantam Dell, 2003)
- Buchanan, Cathy Marie. *The Day the Falls Stood Still.* (Hachette Books, 2009)
- Clark, Margaret Goff. *Freedom Crossing.* (Scholastic Paperbacks, 1980)
- Mayr, Suzette. *The Widows.* (NeWest Press, 1998)
- Moore, Robert C. *Stone House Diaries.* (Local History Co., 2006)
- Oates, Joyce Carol. *The Falls.* (HarperCollins, 2009)
- Urquhart, Jane. *The Whirlpool.* (Sceptre, 1991)

ENDNOTES

1. Abraham Lincoln quote. http://quod.lib.umich.edu/l/lincoln/lincoln2/ 1:6?rgn=div1;view=fulltext, accessed June 3, 2017.

2. Facts About Niagara Falls. https://www.niagarafallslive.com/facts_about_niagara_falls. htm, accessed June 3, 2017.

3. Niagara Falls Erosion. http://getalltravel.info/destinations/canada/niagara/falls_ erosion.html, accessed June 3, 2017. The erosion rates listed for the Falls vary greatly from source to source. One site—Facts About Niagara Falls. https://www.niagara fallslive.com/facts_about_niagara_falls.htm geography, accessed June 3, 2017—makes the claim that the erosion rate is roughly 1 foot every 10 years. Another site, http:// www.onlineniagara.com/niagara-falls-erosion, accessed June 6, 2017, cites that this is true for the Horseshoe Falls but that the American Falls erodes just 2 or 3 inches a year due to the lower flow rate.

4. Facts About Niagara Falls. https://www.niagarafallslive.com/facts_about_niagara_falls .htm

5. The following sites and resources were used to glean a general understanding of the major historical moments in the Niagara region:

 - Klein, Milton M. *The Empire State: A History of New York.* Ithaca, New York: Cornell University Press, 2001.
 - Muhlstein, Anka. *La Salle: Explorer of the North American Frontier.* Arcade Publishing, 1994.
 - http://www.niagarafrontier.com/work.html, accessed October 13, 2017.
 - https://sni.org/culture, accessed October 13, 2017.

6. Photograph of Jean Francois Gravelot. George Stacey, publisher. Albumen print on card mount; mount 8x17cm (stereograph format). Retrieved from the Library of Congress, http://www.loc.gov/pictures/item/2017657298, accessed September 20, 2017.

7. Photograph of Annie Edson Taylor. Zahner, M. H, photographer. [Miagara i.e. Niagara. Mrs. Taylor the first human being to go over falls and lives]. New York Niagara Falls Ontario, 1901. [Niagara Falls, N.Y.: M.H. Zahner, publisher] Photograph. Retrieved from the Library of Congress, https://www.loc.gov/item/2016647628, accessed July 03, 2017.

8. Photograph of "Bobby" Leach and his barrel. New York, Niagara Falls, Ontario, CA. 1911. Photograph. Retrieved from the Library of Congress, https://www.loc.gov/ item/93502920, accessed July 03, 2017.

9. From the article "After Century-Long Wait, Stage Is Set for Man Daring to Cross the Falls." *New York Times*. June 14, 2012. http://www.nytimes.com/2012/06/15/nyregion/nik-wallenda-is-set-to-cross-niagara-falls-friday.html, accessed September 20, 2017.

10. Frederick Law Olmsted quote. http://quoteaddicts.com/1047679, accessed September 20, 2017.

11. The Legend of the Maid of the Mist. http://www.firstpeople.us/FP-Html-Legends/Legend_Of_The_Maid_Of_The_Mist-Unknown.html, accessed June 03, 2017. Note that the spelling of the tribal name "Ongiara" varies depending on the source. I have deferred to the spelling used in referenced source materials throughout this book.

12. Old Stone Chimney's Rich History Deserves to Be Preserved. http://niagarafallsreporter.com/chimney.html, accessed August 2, 2017.

13. Journey Behind the Falls. https://www.niagaraparks.com/niagara-falls-attractions/journey-behind-the-falls.html, accessed September 20, 2017.

14. Quote by Vinita Kinra. http://globalasiantimes.com/by-vinita-kinra-niagara-falls-is-the-hanging-tongue-on-the-face-of-the-earth-drooling-endlessly-over-its-own-beauty, accessed September 20, 2017.

15. The Erie Canal. http://eriecanal.org/index.html, accessed September 20, 2017.

16. The Erie Canal. http://eriecanal.org/index.html, accessed October 12, 2017.

17. Lockport Palace Theater. http://lockportpalacetheatre.org, accessed September 20, 2017.

Through Your Eyes

I'd love to hear how the content in this book shaped your visit to the Niagara region or your appreciation of our community. If there is something that you particularly enjoyed in this book, or perhaps something that you think was inadvertently omitted, please drop me a line at balynchjohnt@gmail.com. I will take your views into account when updating the text for future editions. Please also review the book on Amazon or Good Reads. Your thoughts are appreciated.

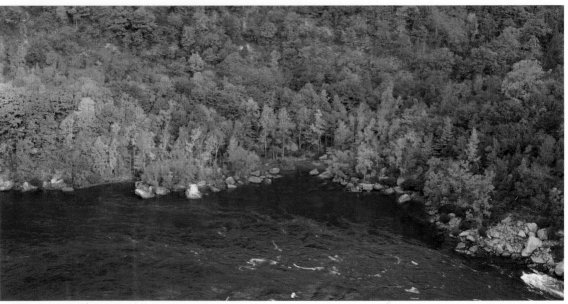

Photographs © Duncan Ross.

INDEX